Penguin Handbooks

Colour Photography

Eric de Maré, A.R.I.B.A., was born in London
in 1910 and studied at the Architectural Associ-
ation. He edited the *Architects' Journal* for four
years, but took to freelancing after the war,
mainly as an architectural photographer. His
books include the Penguin Handbook *Photo-
graphy*, which is the companion to this book,
Britain Rebuilt, *The Canals of England*, *The
Bridges of Britain*, *Time on the Thames*, *London's
Riverside*, *Photography and Architecture*, *Scan-
dinavia*, *Swedish Cross-cut: A Book on the Göta
Canal* and *The City of Westminster: Heart of
London*. His books for children include *Your
Book of Paper-Folding* (with his wife) and
London's River: The Story of a City, which was
runner-up for the Carnegie Award. Industrial
Archaeology is one of his interests, and among
other works he has illustrated with photographs
*The Functional Tradition in Early Industrial
Buildings* (the text is by Sir James Richards).
He has also written two books on Victorian
London: *London 1851: The Year of the Great
Exhibition* for the Folio Society, and *The
London Doré Saw* for Allen Lane The Penguin
Press. He has spent half his life advocating the
philosophy that in an age of machines the
traditional dichotomy between toil and leisure
is a false one, and that the Great Money Myth
should now be on the way out.

Eric de Maré

Colour Photography

with 19 full-colour plates

Everything beckons us to perceive it,
Murmurs at every turn, 'Remember me.'
– Rainer Maria Rilke

Penguin Books

Penguin Books Ltd, Harmondsworth, Middlesex, England
Penguin Books Inc., 7110 Ambassador Road, Baltimore, Maryland 21207, U.S.A.
Penguin Books Australia Ltd, Ringwood, Victoria, Australia
Penguin Books Canada Ltd, 41 Steelcase Road West, Markham, Ontario, Canada
Penguin Books (N.Z.) Ltd, 182-190 Wairau Road, Auckland 10, New Zealand

First published 1968
Reprinted 1971
Second edition 1973
Reprinted 1974
Copyright © Eric de Maré, 1968, 1973

Made and printed in Great Britain by
Hazell Watson & Viney Ltd, Aylesbury, Bucks
Set in Monotype Times

Contents

Introduction

This book has three aims: to outline the principles and historical development of colour photography, to give guidance in its practice to the amateur, and, above all, to discuss its aesthetic. The book is an 'extension course' of my more general Penguin *Photography*, but it is not an 'advanced course', for it is written as much for the beginner as for the expert.

Amateur photography supports a global industry. In the United Kingdom alone, it is said, 15 million amateur cameras are in use with which over 700 million shots are taken a year, one in three now being in colour. In 1964 it was reckoned that £69 million was spent on the pastime altogether, and the figure rises each year. Photography is the true folk art of our technological age – 'the dominant and fascinating and only authentic folk art of the twentieth century', as Sir John Rothenstein has called it. Now colour has added its primitive delight, and to despise the average family portrait or holiday scene in colour because it is not great art would be foolish snobbery. It is for such personal purposes that most amateurs use their cameras – for the simple recording of people and places they wish to remember in colours more vivid and dreamlike than life. Even this unpretentious picture-making is a kind of magic, for which photography, even if it had no other purpose, should be blessed.

By its framing and isolating of a part of the outer world, the camera helps us to see how filled with curious patterns and how colourful the world really is. Having realized this, many

people want to do more with their cameras than make simple records; they want to express themselves through photography – to make their own comments about the way they see things. As the Swiss playwright, Friedrich Dürrenmatt, has said, 'Anyone can take a snap – even a photomat, but not everyone has the necessary powers of observation. Photography is only an art when it makes use of the art of observation. Observation is an elementary poetic process.' Photography is indeed a kind of language; you can use it for trivial talk, for evocative prose, or, on rare occasions, for emotive poetry. This book attempts the almost impossible task of analysing the mysteries which make a colour photograph something more than a mere record.

Black-and-White and Colour

Many claim that colour photography, even at its best, can never be creative. That is a very bigoted view. Photography is a limited medium, but then every medium has its own limitations. Without them, and their acceptance and understanding, no art would be possible in any form. In fact I believe that, in spite of the growing popularity of colour photography and of its rapid technical improvements, black-and-white photography remains the more creative medium precisely because it is the more limited and disciplined. Its images are generally stronger in their impact than those of colour photography. Many works in black-and-white by famous photographers stay sharply in the memory, but how few there are in colour, even when taken by the same masters, of which the same can be said.

All creative photography depends finally on the personal selection of an integrated and immutable formal structure and its isolation by the frame from the surrounding formless flux. When this produces a picture which converts an ordinary object or an insignificant moment of daily life into a significant and

extraordinary symbol, a great photograph has been produced. A composed and expressive unity is obtained by various means such as the direction and quality of light which stresses forms and textures, the choice of lens, control of the light by filters, depth of focus, point of view, processing controls, and so on.

In black-and-white the photographer has to translate in his mind's eye the colours of his subject into a range of tones before he presses the trigger, and that effort alone makes black-and-white in a way more creative than colour. It paraphrases and formalizes more. Structure, texture, and rich tonal quality are all weakened by colour, for colour tends to distract the eye from strong forms and their pure architecture. A decorative prettiness may be gained by colour, and sometimes emotional force too, but drama is often lost, not least the drama of a significant instant of action which will never recur. Light in its various moods has deep emotional meanings for everyone, and black-and-white can often convey those meanings more powerfully than colour.

Most amateurs now rely on the trade to do their processing and printing in colour, for to process colour films and make colour enlargements at home needs more time, skill, equipment and space than most people possess. Thus they lose much of that fun of photography which lies in making fine enlargements; they also lose a good deal of personal control over the results. Printing in black-and-white, however, needs little equipment, and can easily be done at home in the bathroom. I believe that in some ways, black-and-white therefore has more to offer the amateur than colour, and that he should not allow colour to seduce him right away from monochrome under the impression that colour is better and more advanced than black-and-white merely because it has colour. The two media are not in competition; they are different. In any case, while techniques may advance, creative expression does not; it merely changes.

The chief limitation of all photography lies in its having to

discover integrated pictures in the world around us; it cannot create its own world so readily as drawing and painting. It is hard enough to discover and isolate – and thus to create through personal selection – a picture in monochrome photography, but it is even harder to do this in colour. That is because not only does the selection and composing of forms have to be just right, but also the selection, composing and integration of the colours of those forms. The chances of discovering both good form and good colour together in an expressive unity are rare.

Photography and Painting

I am not denigrating colour photography by these comments, but only want to make plain from the start what the aesthetic limitations of colour photography are, so that I can show where, through their acceptance, its unique possibilities may lie.

In spite of its confusion with painting in the past, monochrome photography is now seen to have certain powers possessed by no other medium. It does not try to compete with painting or the graphic arts in any way, but stands proudly on its own. Colour photography, on the other hand, has closer aesthetic affinities with painting. Yet, if we relate the infinite freedom of the painter to make any forms he likes with the sensual textures and solidity combined with translucence he can achieve with pigments to the restrictions imposed on the colour photographer with his flat dyes, the battle is obviously lost before it has begun. We must find out what colour photography can do which no other medium, even black-and-white photography, painting, or any graphic art, can do.

The puritan conscience would say that painting is better than photography because it requires more effort. That is beside the point. The distinguished American photographer, Eliot Elisofon, writes well in his book, *Colour Photography*:

The actual physical recording of the photographic image is the least vital aspect of photography. No one seriously claims that the billions of snapshots made today are works of art and some say none are. Photographs that transcend the medium of their making by infusing the subject with values, that inspire the viewer with new ideas and new dimensions, and that give the audience a richer world to look at and understand surely must be considered art. There are not many photographers who are great artists for the same reason that there aren't many great artists in other creative fields either.

Whereas the technique of painting is hard to acquire, that of colour photography is fairly easy. What is difficult in either technique is to transcribe into their scope and limits a fresh and personal vision. All the visual arts are linked by a basic grammar of line, form, texture, colour, and their relationships. This sensible and liberal view was adopted by the short-lived but influential Bauhaus school of design in the 1920s and it is one which is now fairly widely accepted in schools of art. After all, seeing is seeing, by whatever means we try to express and communicate our views.

One special quality of colour photography is its ability to produce a multiplicity of colours which are far too subtle to be captured by paint and brush. I know a talented artist who gave up painting to concentrate on colour photography because he found that only by its means could he capture the wide but harmonious range of coloured forms and patterns in certain close subjects which excited his eye.

The colour camera has a power of revelation which can thrill and stimulate visual artists in every field. It can show us things we have never seen before, even where the eye by itself is useless. Of course, to render something visible which was formerly hidden is not necessarily to create; it is merely to discover. As Paul Klee remarked, 'Art does not render visible; it *makes* visible.' All the same, photography, both in colour and black-and-white, has widened our experience enormously, and

11

in doing so has served as a creative stimulus. It is a wonderful eye-opener, and we are the richer for its revelations from the air, below the sea, through the microscope, by the stroboscope, by the X-ray and infra-red ray, and by the high-speed exposure which can capture movement too rapid for the eye to see and which has now become possible down to the fantastic speed of one millionth of a millionth part of a second. (No one realized exactly what happened to the legs of a galloping horse, for example, until Edward Muybridge made his serial exposures in the 1870s.)

The effects on vision of lenses, from the widest fish-eye to the narrowest telephoto, have been strong; so have those of the blurring of backgrounds by short depth of focus, and the blurred image caused by movement. All these new revelations have undoubtedly affected everyone's way of looking at things, not least that of painters. The impact of photographic vision on painting can indeed be seen at least as far back as Degas, who was himself an enthusiastic photographer – perhaps as far back as Corot, or even Delacroix.

It may seem that the photographer is completely trammelled by the colours that already exist in his subject, whereas the painter can choose any colours he wants. But this is not so. In a studio colours can be controlled by coloured lights and filters to the photographer's choice, and even where colours cannot be so firmly controlled, as out-of-doors, much can be done by the judicious use of colour filters. In making a colour print great control of colours is also possible. Here, in the deliberate distortion of colours, a good deal of creative expression can find release in colour photography.

Wide landscape is the most popular subject among amateurs; yet this is perhaps the least rewarding of subjects in colour photography. A reason for its popularity may be that painters have made us look at landscapes with aesthetic pleasure. In fact, Claude, Poussin and other landscape artists directly in-

fluenced the making of the English landscape of the eighteenth century. Natural scenes have thus become 'picturesque' to us because the painters opened our eyes in a way that photography cannot expect to do in a sphere where 'nature imitates art'. It is in the 'landscape' of the close-up that colour photography comes into its own. The renowned photographer, the late Robert Capa, gave good advice to all photographers when he said, 'If your pictures aren't good enough, you aren't close enough.'

Apart from its revelatory power of finding and isolating the significant close detail, photography has one tremendous advantage over drawing and painting: it can freeze a moment of action, an enthralling mood of light, or an expression on a human face which would be too fleeting for capture by brush or pencil.

When used with subtlety, originality, sincerity and educated taste, colour photography can have an enchantment all its own, particularly in the brilliance of a transparency isolated by darkness from its surroundings in a viewer or projected on to a screen. When the colours and lighting are right, they can even achieve a strange three-dimensional quality. Photographic colour prints are less fascinating, partly because they are generally seen with a duller, reflected light in a lighted room, and partly because their surfaces have a boring texture. At the present technical stage, which is likely to improve rapidly, prints also fade rather fast in the light, even in a few months.

Although the natural media for the photograph may be newspapers, magazines and books, I see no reason why colour photographs should not also be used directly for wall decoration, provided the present weaknesses of fading and lack of pleasing surface texture can be overcome. The sophisticated may shudder at this idea, but are they not too prejudiced? A cause of this prejudice may lie in the poor quality of the colour print at its present stage of development and also that general

13

mediocrity of colour photographs, which has made for displeasing associations. Yet no reason exists why beautiful colour prints with rich, subtle colours and textures should not be produced before long, notably in powerful close-ups having the quality of abstracts – perhaps even in the form of large murals.

Many people still believe that the more skilfully 'naturalistic' a painting is, the greater it becomes as a work of art. That may be one reason for the popularity of colour photography in that 'realism' can now be reproduced (and therefore it is thought 'art') merely by pressing the trigger of a camera. Although the first pictures men ever made were probably not intended to copy nature precisely but to serve as powerful, magical symbols, painters tried for centuries to interpret nature with ever-growing insight and technical skill, a major advance in this attempt being the discovery of perspective. 'From one point of view,' wrote Roger Fry in his *Reflections on British Painting* . . .

the whole history of art may be summed up as the history of the gradual discovery of appearances. Primitive art starts, like that of children, with symbols of concepts. In a child's drawing of a face a circle symbolizes the mask, two dots the eyes, and two lines the nose and mouth. Gradually the symbolism approximates more and more to actual appearance, but the conceptual habits, necessary to life, make it very difficult, even for artists, to discover what things look like to an unbiased eye. Indeed, it has taken from Neolithic times till the nineteenth century to perfect this discovery. European art from the time of Giotto progresses more or less continuously in this direction, in which the discovery of linear perspective marks an important stage, whilst the full exploration of atmospheric colour and colour perspective had to await the work of the French Impressionists.

Even the Impressionists tried to interpret nature, though in a new way. The Post-Impressionists became less concerned with representation and more with formal values, until the Cubists produced a revolution by resigning the effort to interpret nature

14

as *trompe l'œil*. Clearly, photography was partly responsible for this revolution because it forced painters to think afresh; it relieved them of the burden of trying to achieve a transcription of 'reality' by forcing them to reconsider their basic aims and assumptions. So new freedom and vitality were born.

Up to this revolution, photography was considered to be an easy imitation of painting, and the two media were badly confused. Fox Talbot began the misconception by calling photography 'photogenic drawing' and 'the royal road to drawing'. A revealing comment was made, somewhat hysterically, by the painter Paul Delaroche when he saw his first Daguerreotype, 'From today painting is dead!', while Ingres confessed, 'It is this accuracy (of a photograph) that I should like to achieve; it is wonderful but one dare not say so aloud.' It is significant also that Daguerre's occupation, before he concentrated on his invention, was the painting and staging of huge romantic illusions for his Diorama theatres. In fact, photography was partly the outcome of the desire for an optical realism which most painters had been trying to achieve for centuries within the restraints of their medium. It was *trompe l'œil* they sought, and in the end photography brought disillusion with that purpose.

Although the relationship between painting and photography has been clarified, confusion persists to some extent. Sir John Rothenstein wrote wisely in his introduction to *The World of Camera*:

No doubt because photography became popular at a time when painters were preoccupied as never before with the closest possible representation of a phenomenal world, it filled them and their friends with consternation. It threatened to surpass their own art in its most cherished field. And it quickly, and justifiably, won recognition as an art in its own right. ... Few painters today, I fancy, would presume to despise the finest photographers.

Realism and Illusion

The core of the matter lies in metaphysics, where aesthetic speculation always ends in a final and impenetrable mystery. But certain thoughts are clear. Neither painting nor photography can ever be truly realistic, since reality – whatever that may ultimately be – can never be seen. Yet in spite of the fine formal abstractions photography can achieve, both in black-and-white and colour, many painters still regard it without respect because they believe it is fettered by 'reality' – that it can only, so to speak, record an *objet trouvé*, a discovered object. But the camera always lies. 'Photography is unreal,' said Jean Cocteau, 'it alters values and perspectives.'

What is reality? The very act of seeing is to a large degree creative, for we never perceive reality as such, nor can we ever do so. Seeing is the result of training from birth and of the effects of the cultural inheritance on that training. The mind creates images from the rough, raw material of the light waves picked up by the optic nerves and transmitted upside-down to the brain, where it is transmuted, the right way up, into significant forms which help us to survive. We *learn* to see from birth. Someone born blind, who gains sight in later life, must learn to see, and this may take many difficult months, even years, by the gradual coordinating of sight with the other senses in the telephone exchange of the brain and along the wires of the whole nervous system.

From the very limitations of all our senses we are able to create a human world from the chaos of that so-called reality which we do not, and may never be able, fully to comprehend. Seeing is too often taken for granted, but it is by no means the simple, obvious activity it is generally taken to be. It is, indeed, the most extraordinary and inexplicable mystery. So is its expression in the visual arts, not least in photography. What we

see is a concept created in our minds from that small part of the whole electromagnetic wave system called light (itself an unfathomable mystery) acting through the eye, which is, in fact, a mechanism rather like a camera.

'Aesthetics has surrendered its claim to be concerned with the problem of convincing representation, the problem of illusion in art,' writes Professor E. H. Gombrich in his renowned work, *Art and Illusion.*

In certain respects this is indeed a liberation and nobody would wish to revert to the old confusion. ... The illusion has grown up that illusion, being artistically irrelevant, must also be psychologically very simple. ... The Greeks said that to marvel is the beginning of knowledge, and where we cease to marvel we may be in danger of ceasing to know. ... We can never neatly separate what we see from what we know.

The late Bernard Berenson expressed the matter well in his *Aesthetics, Ethics and History*:

The eyes without the mind would perceive in solids nothing but spots or pockets of shadow and blisters of light, checkering and criss-crossing a given area. The rest is a matter of mental organization and intellectual construction. What the operator will see in his camera will depend, therefore, on his gifts, and training, and skill, and even more on his general education; ultimately it will depend on his scheme of the universe.

William Blake put the matter more succinctly when he said, 'I see through my eyes, not with them.'

This is not a new notion, for back in classical antiquity Pliny wrote, 'The mind is the real instrument of sight and observation; the eyes act as a sort of vessel receiving and transmitting the visible portion of the consciousness.' As Professor Gombrich points out, there is no rigid distinction between perception and illusion since all seeing is interpreting and never just registering; it is the reaction of the whole organism to the

17

patterns of light that stimulate the back of our eyes. 'Nobody,' he writes,

has ever seen a visual sensation, not even the Impressionists, however ingeniously they stalked their prey. ... All artistic discoveries are discoveries not of likenesses but of equivalences which enable us to see reality in terms of an image and an image in terms of realities. ... A representation is never a replica.

So, however we may see, and however we may express what we see, we never see or express reality. What we see and call reality changes with the years, and there is no doubt that the discoveries of science in our own remarkable era have deeply affected the way we see things, including science applied to photography. Even the so-called 'naturalistic', domestic scenes of the Dutch school and the anecdotes of the Victorians were formalizations, the organizing of 'nature' in a selected convention, abstractions of a sort. To quote Gombrich again:

One is tempted to say that in contrast to Monet, Frith leaves nothing to the imagination, but in fact, there is no representation of which this can ever be true. ... The amount of information reaching us from the visible world is incalculably large, and the artist's medium is inevitably restricted and granular.

Even sight itself must be a personal, symbolic, selective formalization – an abstraction. Ask a dozen people to take a photograph of a single subject in any way they feel inclined, but using the same make of camera and the same type of film; then, in spite of the common and mechanical nature of the means, the products will all be surprisingly personal and different.

Apart from opening our eyes to new sights and patterns which had been invisible before, photography can help us to see old things in new and unfamiliar ways. Even the painter's eye is conditioned by what he sees in the world around him in his own

18

way, however non-figurative and apparently abstract his crea-
tions may seem to be. Action painting, for example, with its
reliance on rapid, unconscious control, must have been dis-
tilled from what the mind and memory have absorbed through
the eyes from the outer world, however unrelated this may
seem on the surface to the optical experiences of life. In every
convention, images stored deeply in the memory are the bricks
with which the artist builds. Gombrich makes an interesting
assessment of action painting with 'its absence of any meaning
except the highly ambiguous meaning of traces'. If this game
has a function in our society, he writes, 'it may be that it helps
us to "humanize" the intricate and ugly shapes with which
industrial civilization surrounds us ... the deserts of city and
factory are turned into tanglewoods'. Photography can also
find order and meaning in tanglewoods, especially in the close-
up.

The Age of the Photographic Image

Purely as a new means of record and communication photo-
graphy has become one of the prime visual forces in our lives,
as important in its way as the printed word. It can record not
only the intimate and the personal but also the socially signi-
ficant; so it has become the most valuable means of recording
social history for the future. Its uses in purveying information
of every sort are too many to list. Its images, whether as stills
or moving pictures, may become more important than the
printed word, particularly in education through visual aids.
It can also be a potent means of educating the eye, and a most
enjoyable one, available to anyone with a few pounds to spare.
And one of its greatest assets lies in its ability to cross language
barriers; it is the Esperanto of sight.

Nigel Gosling, the art critic of the *Observer*, has written
perceptively:

Pictures, in fact, came first. ... Actual groups of written characters appeared late in man's development, long after picture imagery. It was the invention of printing which gave the Word a colossal boost. For centuries it has dominated our mental scene, to the detriment of pictorial language. But today all the signs are that its power is on the decline. A second invention – photography – totally changed the situation. ... Photography's children, films and television, have completed the process. ... Yet the old print-puritanism of our grandfathers still persists. ... A whiff of the satanic sulphur which used to hang over the theatre clings to the photograph especially if it is coloured ... but the fact remains that for a huge proportion of our population the normal way of absorbing facts, generating emotion, or undergoing exhortation, is now partly visual. ... The gap between artist and audience is closing, for they are learning to talk about the same things. For good or for ill we are in the age of the image.

This book attempts to provide a small contribution to the better understanding of one kind of image. To echo the fair comment of that colourful figure in the world of photography, director of the recurrent international Photokina exhibition, Fritz Gruber, 'In terms of traditional art, photography is not an art but I couldn't care less. It is *the* contemporary means of expression.'

Part One

Chapter 1 | *How It Works*

The better way to apply a technique like colour photography is not to learn the rules parrot-wise but to understand both its general principles and its historical development from its origins. Then common sense will supply a ready answer to most problems.

The Spectrum and the Eye

As Newton discovered, the white light to which daylight approximates is a combination of seven colours. In their order of wavelengths they are: red, orange, yellow, green, blue, indigo, violet. (For the memory: Richard Of York Gained Battles In Vain.) This can be demonstrated by painting sectors of the colours on a disc which, when revolved, will give a whiteish impression. These seven colours, which make up white light, become separately visible in the form of the spectrum when the light has passed through a glass prism. The same prismatic effect can be seen when raindrops break up the light to form a rainbow. Red has the longest and violet the shortest wavelength, and that is why a glass prism breaks up white light into the separate colours; when it enters the glass, the light is slowed down by the denser material, and is thus bent or refracted; on re-entering the air it is bent again, but, having a different wavelength, each colour is bent at a slightly different angle to the next; those with shorter wavelengths are bent more than those with the longer ones, so producing the spectrum band of the seven colours.

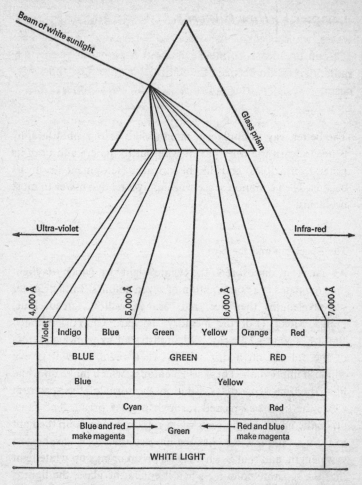

All the other electromagnetic waves lie on one side or the other of the visible spectrum; beyond the red end are the infra-red or heat rays, and beyond the violet at the other end are the ultra-violet. We cannot see infra-red or ultra-violet rays but both kinds can affect colour films, particularly the latter. Beyond the infra-red lie the Hertzian waves which at

their far end contain the radio waves, and then come sound waves, while beyond ultra-violet lie X-rays and gamma rays. The sun broadcasts to the earth about one quarter of the full radiant spectrum between the long radio waves and the short cosmic waves; of this solar energy one third is ultra-violet, three fifths is infra-red, and the rest – only one fifteenth part – is composed of visible light waves, a form of energy travelling at 186,000 miles a second through space.

It is interesting that the different colours of the visible spectrum have very slightly different temperatures in physical fact as well as emotional associations, as Sir William Herschel discovered in 1800 with the use of a thermopile.

The waves are measured in Ångström Units (Å) between about 4,000 at the violet end to about 7,000 at the red end, the unit being a hundred-millionth part of a centimetre.

According to the theory associated with the names of Young and Helmholtz, the eye responds to three distinct regions of the spectrum: violet-blue (about 4,000 to 5,000), green-yellow (about 5,000 to 6,000) and orange-red (about 6,000 to 7,000). Together the three regions form white light. Controversy continues about this three-colour theory of vision, but for most practical purposes, such as colour photography, it works well in that any colour can be seen in normal vision by mixing the right amounts of blue-violet, green-yellow, and orange-red.

The eye is most sensitive to green-yellow, slightly less to orange-red, and least of all to violet-blue. In other words saturated violets and blues look darker than saturated yellows, greens, and reds.

No modern colour film records colours directly. The colours are first recorded on three black-and-white emulsions as colour tones close to the degrees of luminosity in which the eye sees them, and the tones are then transposed into three dyes during processing in the manner to be described later.

The colours of the spectrum can be divided into three equal

25

parts of blue-violet, green-yellow and orange-red, making for practical photographic purposes the three luminous colours of BLUE, GREEN and RED. Each takes up a third of the spectrum and, as we have seen, together they form white light. By combining these three in different proportions we can produce any colour. That is the basis of all colour photography, all colour printing, colour cinematography and colour television.

Additive and Subtractive Colours

Blue, green and red are called the Primary, or Additive, colours, and combining these primaries to make other colours is called an Additive process. The removal of colours to make other colours by filtering or absorption is called a Subtractive process. Today most colour photography is based on the Subtractive process. If red light and green light (not pigments) are mixed (for example, by overlapping two projections, one red and one green), yellow is produced by the additive process. If blue is removed from white light, yellow is also produced but by the subtractive process, a case being a daffodil which looks yellow because it subtracts or absorbs blue from the white sunlight falling on it, and reflects green and red. Transparent yellow filters of glass or gelatine, which are used a good deal in photography in front of lenses to control the colour content of the light falling on to the film emulsions, are also subtractive in that they absorb one of the primaries and transmit the other two; a yellow filter, for example, absorbs blue and transmits green and red.

A black object absorbs all the light falling on it and reflects none. A white object reflects all the colours of the white light falling on it. A coloured object reflects its own colour and absorbs, or subtracts, all the other colours. A grey object absorbs an equal amount of all the colours and reflects an equal

amount. This adding and subtracting of colours is important in the processes of colour photography, as we shall see.

Red added to green produces yellow, red added to blue produces magenta (a kind of mauve), and blue added to green produces cyan (a greenish blue). YELLOW, MAGENTA and CYAN are called the Secondary, or Subtractive, colours. Each covers two thirds of the spectrum (see diagram, page 24). (These Secondary colours of the photographer, who deals directly with light, are often called Primaries by the painter, who deals with solid pigments, and confusion sometimes arises as a result.)

The opposite colour to yellow (red plus green) is blue; blue is thus called the complementary colour to yellow because together blue and yellow make white. The complementary to green is magenta (blue plus red), while the complementary to red is cyan (blue plus green). In the three-colour process of photography therefore:

Yellow (red-green) on a negative film produces its complementary of *blue* on a positive colour print made from the negative.

Magenta (red-blue) on a negative produces its complementary of *green* on a positive print.

Cyan (blue-green) on a negative produces its complementary of *red* on a positive print.

Because it subtracts green from white light, magenta is sometimes called minus-green. So yellow is minus-blue and cyan is minus-red. (A yellow filter could, for example, be called a minus-blue filter.) Cyan plus magenta thus reverts to blue; cyan plus yellow reverts to green; yellow plus magenta reverts to red. Cyan plus yellow equals green; cyan plus magenta equals blue, and yellow plus magenta equals red, since in each case the complementaries cancel each other out by making white light, leaving only the primaries. The following table may clarify the matter:

27

Colour:	Consists in additions of light waves coloured:	Or it consists of white light from which has been subtracted:
White	Red, Green, and Blue	Nothing
Yellow	Red and Green	Blue
Magenta	Red and Blue	Green
Cyan	Blue and Green	Red
Red	Only Red	Blue and Green (Cyan)
Green	Only Green	Red and Blue (Magenta)
Blue	Only Blue	Red and Green (Yellow)
Black	No light	Red, Green and Blue (White)

The table shows that any colour can be considered either additively or subtractively. It also shows which colours are complementary (negative) to each other, the ones in the left-hand column being complementary to those in the right-hand column – that is they make white light when combined. The matter can also be expressed in the diagram opposite. If you project white light through separate transparent filters of red, green and blue so that their images converge and overlap on a white screen, the centre part where all three overlap will be white, the part where red and blue overlap will be magenta, and the part where red and green overlap will be yellow. But if you project white light through transparent overlapping filters of magenta, cyan and yellow, the centre will be black, while the cyan and yellow overlap will be green, the yellow and magenta overlap will be red, and the magenta and cyan overlap will be blue.

Colour 'Temperatures'

All this is theoretical, and in reality the three primary colours of red, green, and blue are very rarely seen in pure forms; other colours are almost always there in some degree, however

28

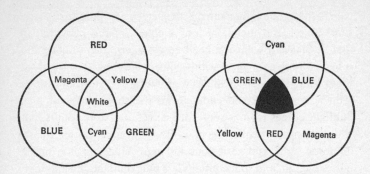

pure a colour may seem to be. Light which is pure white hardly exists in reality either, and even daylight varies greatly in its colour content, a fact which is important to colour photography. Another important fact to realize is that no object will reflect, or absorb, a particular colour if that colour is not contained in the light falling upon it. We have to know what is the colour content of the light falling on what we are photographing if we are to be able fully to control the result. For example, sunlight shining through clouds at midday will contain far more blue than direct sunlight in the early morning or late evening, which may be very red in content. Sunlight high up in mountain country, or by the sea in summer, may contain a great amount of ultra-violet light, which, though we cannot see it, will affect the film emulsion unless an ultra-violet filter is placed before the lens to absorb the unwanted rays; without the filter, shadow areas, for instance, would contain far too much blue in the photograph. Again, daylight contains far more blue than the light from photoflood lamps, which in their turn contain more blue than ordinary domestic light bulbs.

A method of measuring and defining the colour content of particular forms of lighting has been evolved, and its understanding is necessary to anyone who wants to take good colour photographs under different conditions of lighting. The colour

29

composition of a light source is defined by its 'colour temperature'. A piece of metal, such as a poker, placed in a fire, will first be black; it will soon begin to glow red, then orange, and, if heated long enough, it will become white hot. It will pick up the colours of the spectrum as it grows hotter, starting with the long waves of red and ending with the short waves of blue. Sunlight comes from a very hot source, and so it admits light which is nearly white. A photoflood lamp is hotter than a domestic bulb, and so it contains more blue, but it is not so hot as the sun, and so it contains less blue than the sun and more red. A flash bulb with clear glass also contains less blue than sunlight, but a flash bulb with blue glass will compensate for this, and produce light which is nearly the same as sunlight. An electronic flash apparatus, used in photography more by professionals than amateurs, will produce a brief but brilliant light which is close to sunlight. Sunlight might contain nearly equal amounts of red, green and blue, while a domestic bulb might contain 50 per cent red, 30 per cent green and only 20 per cent blue. To measure colour content in terms of heat may seem peculiar, but does ingeniously provide a convenient and workable method.

Pure white light containing the three primaries in exactly equal amounts would be emitted by a perfect radiator of heat, but this is only possible in theory. In fact, the higher the colour temperature becomes the bluer the light becomes and the red rays are weakened. Colour temperatures of light sources are measured in degrees Kelvin, which are given in degrees Centigrade plus 273 degrees. The 273 degrees are added because minus 273 degrees is thought to be the absolute zero, the lowest possible temperature, in the universe, where absolute cold and absolute darkness prevail. Thus the Kelvin scale starts at absolute zero. At about 800° K a radiator would be glowing a dark red, at about 1,200 it would be orange, at 1,300 yellow, and soon it would begin to pick up blue. Candle-light might be

30

about 2,000° K, while sunlight reaching the earth through clouds might be as high as 20,000° K.

Colour films are more sensitive to changes in colour temperatures than the human eye, and so they often produce results which seem unnatural, but are, in fact, more correct in their interpretations than those of the eye. Indeed, colour films can be noticeably affected by variations in colour temperature as small as 100° K. Manufacturers of colour films specify the colour temperature for which their films are adjusted. Thus a daylight-type film may be made for 'correct' colour interpretation for sunlight at 5,800° K. So, if 'correct' colour rendering is wanted on such a film when using light sources which are different in their colour temperature from sunlight at 5,800° K, a compensation filter will have to be used in front of the camera lens, probably with an increase of exposure. Such filters shift the colour temperature either towards the blue end of the spectrum if blue or towards the red end if amber. (Filters are discussed later in a practical way.) In order to take a portrait with photoflood lamps on a daylight-type film, for example, you would need a blue filter over the lens to increase the colour temperature of the light reaching the film, and then exposure might have to be increased as much as four times. An alternative method would be to place blue filters not over the lens but in front of the lamps. But films are made for use with photoflood lamps without the need for a filter. Films adjusted to daylight can be used without filters with blue flash bulbs or with electronic flash, since the colour temperature of the three sources is more or less the same.

If a film is used with light of a colour temperature for which the film has not been adjusted and without a compensation filter, the result will show an overall colour cast; a daylight film used with photoflood lamps, for instance, might show a distinctly orange cast, while a film made for artificial light but used in daylight would show a distinctly blue cast.

So, in order to control the effects of light on a colour film we must know: (1) the sensitivity of the film we are using to different colours – that is the colour temperature in degrees Kelvin for which it is adjusted, (2) the colour temperature of our light source, (3) the effects of different compensation filters on the film we are using, together with the extra exposure each filter demands. (A lens can affect colour results on a film, and may act to a small extent as a colour filter, but rarely to a noticeable extent; all modern camera lenses are now colour corrected in any case.)

Meters which purport to measure the colour temperature of a light source are made, but so far they have not been very successful. A colour meter at moderate price which works really well would be a help to colour photographers and will, no doubt, appear sooner or later. Meanwhile we shall have to rely on film-manufacturers' information, and knowledge gained by practice and experience, and the reading of books like this one, if we are to obtain the precise colours we want. Such colour need not always be 'natural'; indeed deliberate distortion of colours can be a creative help in colour photography. Sometimes interesting results in colour distortion are even obtained by accident, as they occasionally are in painting.

Here is a reference table of light sources and their approximate colour temperatures in both degrees Kelvin and Mireds, another scale which will be explained.

From the table we can see how variable in colour temperature daylight can be from the bluest north light to the reddest dawn or evening glow. It differs not only from hour to hour but from place to place according to the atmosphere's humidity. Lamps also vary; a new domestic bulb will have a higher colour temperature than an old one, and the temperature may drop 300 degrees during the bulb's lifetime. We can now see that the achievement of precise colours on a colour film can be a tricky business.

Light source	Degrees Kelvin	Mireds
Candle	1,600 to 2,000	625–500
100-watt domestic tungsten bulb	2,900	345
500-watt studio lamp	3,200	312
Photoflood lamp	3,400	294
Fluorescent tubes, 'warm white'	3,500	286
Flashbulb, clear glass	3,800	263
Flashbulb, blue glass	5,500	181
Electronic flash lamps	5,000 to 7,000	200–143
Fluorescent tubes, 'daylight'	6,000	166
Sunlight, morning or afternoon, in England	5,000	200
Sunlight, midday, summer, England	6,000	166
Daylight, overcast sky in open	7,000	143
Daylight, overcast sky in shade	8,000 to 9,000	125–111
Daylight, two hours before sunset or two hours after sunrise	4,500	222
Daylight, half an hour before sunset or after sunrise	2,000 to 2,500	500–400
Blue sky with clouds in shade	10,000 to 15,000	100–67
North light, blue sky in shade	15,000 to 27,000	67–37

The three most important colour temperatures for films are 5,800° K for daylight-type films, 3,400° K for films balanced for photoflood lamps, and 3,200° K for films balanced for the slightly warmer studio lamps, such as Photopearl and Nitrophot. Projector lamps, incidentally, are at 3,200° K.

Colour temperatures can be measured not in degrees Kelvin but in Mireds. This is a more convenient system to apply when using compensation filters because the same filter will produce the same numerical colour shift from one colour temperature to another anywhere along the scale, whereas the Kelvin measurements vary numerically. For instance, if you want to convert a light, which is slightly too blue at 6,500° K, to suit

C.P. – 2

33

a daylight-type film adjusted to 5,800° K you would use a pale amber filter. The same filter would be needed to convert light from a photoflood lamp at 3,400° K to suit a film adjusted to 3,200° K. Yet the differences in degrees Kelvin in the first case is 700 and in the second only 200. The Mired measurement makes the numbering the same for both cases, and this is a convenience when designating filters according to their depth of colouring.

Degrees Kelvin can be converted to Mireds by the formula:

$$M = \frac{1,000,000}{K}$$

where M stands for Mireds and K for degrees Kelvin. Thus 6,500° K equals 154 M, and 5,800° K equals 172 M, giving M a difference of 18. 3,400° K equals 294 M and 3,200° K equals 312 M, also giving M a difference of 18. The common difference is called the 'Mired Shift' of the particular filter. A filter giving a shift to red is given a positive Mired value, and one giving a shift towards blue is given a negative Mired value. In the case above, therefore, the Mired Shift would be +18. Note that the higher Mired value represents the lower Kelvin value, and vice versa. Now a tendency is growing to use Decamireds (DM) instead of Mireds (M), one DM equalling ten Ms. It cuts out naughts.

But at the start, do not worry too much about all this. With a modern camera having fully automatic exposure control, zone focusing selection, and a film like Kodachrome with its admirable processing service, most normal subjects in average daylight can be successfully and easily photographed by any beginner. Only when very precise colours are wanted, or when conditions are abnormal, is filtration needed. In any case, colour appreciation varies in a subjective way. We often think we see colours which are not really there at all, and we fail to see colours which are in fact there.

Believing is not Seeing

One subjective reaction of which the colour photographer must always be wary is the tendency to discount blueness, particularly in shadows on sunny days when the sky is blue. We think that shadow areas represent merely a lack of general light – that they are merely grey – but this is rarely so. The most ubiquitous colour in outdoor photography, whether in sunshine or under an overcast sky, is blue; it is always there in greater quantities than the mind likes to accept, but the film will record it truthfully. A pink haze filter will serve as an antidote to much unwanted blueness.

Another falsification by the mind is the removal of a colour cast from, say, the human face, which we tend to think of as a kind of yellowish pink. But flesh reflects colour strongly and, if a face is close to foliage or green grass, a green cast may be reflected from the features of which we are not aware, and this the film will record; in the same way a red brick wall may throw a reddish tinge on to a face if it is close enough to it.

We may see a swan floating on a blue lake as pure white, but a film may accurately show it as being pale blue, owing to reflection from the water. Similarly, a dress we know to be white, and actually see as white in our mind's eye, under varying conditions of light, may appear on a film as being pale green if photographed under a leafy tree. Shadows in the snow tend to be far more blue than we at first believe them to be. Nor in the light of early morning or late evening do we register how much more orange everything is compared with the light at midday, for our eyes have been adjusting themselves slowly as the colour of the light has changed. We may know that a sheet of paper is white; it may indeed be so in midday sunlight, but in electric light it is decidedly yellow; nevertheless we deem it still to be white, and see it as such. Memories and associations

35

affect our personal mental interpretations of colours, and also our emotional reactions to them, far more than we are consciously aware.

I first realized how blue north light can be many years ago when recording some paintings in colour in a museum in Stockholm. The light reflected from their white surrounds seemed to me to be pure white, but I was disappointed to find that, whereas the pictures photographed in rooms facing south were correct in their colour values, those taken in the rooms facing north had a distinctly blue cast all over them. With more experience I would have used a pale yellow filter for the north-light shots to neutralize the blueness in the light.

By looking more carefully, and by practice and training, you can educate your eyes to see colours more accurately than the eyes of most people do, but the eye is an unreliable instrument at its most practised and best. It tends to adapt itself automatically to the colour temperature of light, and we assume that objects have the colours with which we normally associate them. So the eye tends to see the apparent colours as constant, however much the colour content of the light may change. The real differences become apparent only when direct comparison of the effects of different light sources can be made at the same time. When a slide is projected on a white screen in a dark room, its colour values may be quite false; the whole may even have a colour cast; yet the eye will tend to eliminate such distortions. On the other hand, when a colour print having distortions of colour is seen in daylight surrounded by other objects, the distortions will be obvious. That is why the colours of a transparency intended for projection need not be so 'correct' in colour values as those of a print to be seen in normal surroundings – that is if naturalism is the aim. This, however, is not true in a motion picture where successive scenes vary in their colour balances, because then comparisons make their differences apparent. (Note that a positive colour

transparency should be seen against tungsten light rather than daylight, since it is made to be seen as a projection from an artificial light source.)

The Tri-pack Colour Film

Most people now use these films producing transparencies which can be seen in their correct positive colours in a viewer, or against a light, or thrown enlarged from a projector on to a white or silver screen. They are called reversal films, as distinct from the negative films from which prints are made. In the negative films, as we have seen, blue is represented by yellow, green by magenta and red by cyan. (Such negative films were not possible with the earlier additive systems.)

The modern subtractive, multi-layer, or so-called tri-pack colour film is made up, not of three layers as one might suppose, but of seven layers, all very thin. First comes the transparent colourless base which is backed by an anti-halation coating to prevent unwanted reflections affecting the emulsions. On the base lies the red-sensitive emulsion, followed by a clear gelatine base on which lies the green-sensitive emulsion. A yellow filter is then interposed, and finally at the top comes the blue-sensitive emulsion. The yellow filter, which is dissolved away during processing, is there to prevent blue rays penetrating to the green- and red-sensitive layers.

The three emulsions of the tri-pack colour film are like three separate black-and-white emulsions in that they are composed of silver salts which turn black when processed after exposure. The top, or blue, layer is of the very early type of emulsion called 'Ordinary' which is sensitive only to blue and violet light. The green layer is orthochromatic, and sensitive only to blue and green; because the top layer and the barrier of the yellow filter have absorbed all the blue rays, this second layer will record only the green rays. The bottom, or red, layer is

37

sensitive to red and blue, but only slightly to green; it is a more or less panchromatic emulsion; since the layers above it will have absorbed the green and blue rays, this bottom layer will be sensitive only to the red rays.

During the first stage of the processing of the film after exposure, the three layers are developed like a single-layer black-and-white film. A different tonal image will be formed on each of the three emulsions according to its controlled sensitivity to the three primary colours; the effect will be that of three superimposed separation negatives. In the case of a reversal (positive) film, re-exposure to a bright light is given so that the remaining undeveloped silver can be developed. The film then goes into a second and special developer which deposits the right colour dye on each layer according to the effects on each layer of the second exposure and its consequent reduction of silver in the image; dye images are formed on the three layers by coupling where no negative silver images were formed by the first development; so the blue layer will take on a yellow dye, the green a magenta, and the red a cyan. Now the film is quite opaque since all the silver has been blackened. The film is finally bleached and fixed, and all the silver deposits are washed away, together with the yellow filter, leaving only the positive colour images in the three layers, all the unwanted

dyes having been destroyed in proportion to the amount of silver developed.

In a reversal film, therefore, the original positive red in the subject is reproduced by combining yellow and magenta, green is reproduced by combining yellow and cyan, blue by combining magenta and cyan, black by combining magenta, cyan and yellow, and white by no dyes at all. In other words the latent images produced by the original exposure on the three emulsions are developed and subsequently entirely eliminated; it is the second exposure in a bright light, and the second development of the new silver images with the coupling of these with the three dyes of secondary colours, which produce the positive image. In a negative colour film, however, the first development deposits the dyes as the silver is reduced according to the original exposure; then no re-exposure takes place; the red emulsion takes on cyan dye, the green emulsion takes on magenta, the blue emulsion takes on yellow, black will be represented by no dyes at all, and white by all three dyes. (The processing of colour films at home will be described in practical detail later, the above description being merely an indication of the principles on which colour films acquire colours.)

The above description applies only to those films incorporating colour couplers, most of which can be processed at home by the amateur. In the 35 mm. Kodachrome the couplers are present in the developing solutions; their processing is complex and must be done by the makers themselves, the cost of processing being included in the price of the films.

Chapter 2 | *A Short History*

Although colour photography arrived in its present popular form only in the mid-1930s, its history is very much older than that. Both Nièpce and Daguerre, who, together with Fox Talbot, fathered photography during the 1820s and 1830s, tried to reproduce colours – but without success. Daguerreotypes and Calotypes were often hand-tinted, but that, of course, was not colour photography.

The study of colour itself may go back at least to the second century A.D., when Ptolemy discovered additive light mixtures with rotating discs. Isaac Newton, the discoverer of gravitation, however, began the scientific study of colour, and he was the first to analyse white light by breaking it down through a prism into its coloured components in the spectrum. As well as the study of light itself by physicists like Newton, Young, Helmholtz, and others, the development of organic colour chemistry was needed for the invention of colour photography, a science in which the work of Sir William Perkin was fundamental, for it was he who produced the first organic dye known as Perkin's Violet.

How it Began

The true start of modern colour photography occurred in May 1861 when the great Scottish physicist, Sir James Clerk Maxwell, who formulated the electromagnetic theory of light, demonstrated dramatically at the Royal Institution in London that any colour can be obtained by mixing light of the three

primary colours of red, green and blue in varying proportions. He based his experiments mainly on the work of the English physicist, Thomas Young (1773–1829), which were later developed by the German scientist, Hermann von Helmholtz (1821–94). Young, who was the first man to advance the wave theory of light, wrote in 1801:

As it is almost impossible to conceive that each sensitive point of the retina (of the eye) contains an infinite number of particles, each capable of vibrating in unison with a given light wave, it must be assumed that this number is limited for example to three principal colours, red, yellow and blue.

In fact, the six million colour-sensitive cones of the human eye are, as we now believe, of three kinds: blue-sensitive, green-sensitive and red-sensitive. By being stimulated in varying degrees these cones enable the eye to distinguish several million different colours. For his demonstration Clerk Maxwell made three photographic exposures of a tartan ribbon on black-and-white photographic plates, one through red glass, one through green, and the third through blue. Positive lantern slides were printed from the negatives and each was projected by a lantern through its appropriate colour filter to coincide in superimposed register on the screen to form a fairly effective colour photograph of the tartan. That was the first additive system of colour photography.

The first subtractive system was announced independently during the 1860s by two Frenchmen who were quite unknown to each other but had both been experimenting along similar lines. Their names were Charles Cros and Louis Ducos du Hauron. Later the two worked together and evolved several methods of three-colour photography. In 1869 du Hauron published a remarkable small book, *Les Couleurs en Photographie, Solution du Problème*, in which all the main principles

41

of modern colour photography, both additive and subtractive, were laid down.

Du Hauron's subtractive method was as follows. He took three separation negatives behind green, orange, and violet filters, and from these he made positives on sheets of bichromated gelatine containing coloured pigments of red, blue, and yellow – that is the respective complementaries of the negative colours. The carbon prints were then superimposed in transfer on a mount either on paper to make a print or on glass to make a transparency. They were called Heliochromes.

How it Developed

The ideas of Cros and du Hauron were far ahead of the technical possibilities of their times, and many years passed before they could be fully applied in practical ways, notably when the orthochromatic plate arrived with its greater sensitivity to all the colours, as compared with the early plates which were over-sensitive to blue and violet. Clerk Maxwell, Cros and du Hauron all had to work with collodion wet plates and so they had to give very long exposures for their greens and reds. The lack of black-and-white plates which were sensitive to all colours was the main obstruction to the practical development of colour photography. Then in 1873 Hermann Vogel of Berlin discovered that the current collodion plate could be made more sensitive to green by bathing it in certain aniline dyes, and this led to the orthochromatic plate. Not until 1906, however, did the panchromatic plate appear and this almost completely solved the problem of the colour sensitivity of monochrome plates by making them sensitive to all colours, including red. So the panchromatic plate helped fundamentally to solve the problem of the colour photograph.

An eventful year for colour photography was 1891. Then Gabriel Lippmann, a professor of physics at the Sorbonne,

obtained remarkable colour photographs by using Interference. Newton had described this phenomenon, which can be seen, for example, in soap bubbles and in oil patches on wet roads, and in 1868 W. Zenker had pointed out the possibilities of interference heliochromy. Lippmann used a plate coated with silver bromide placed in contact with a bath of mercury which served as a mirror. At exposure stationary waves affected the emulsion of silver salts – waves produced by the 'interference' between the direct light entering the camera and the reflected light from the mercury mirror. The plate was developed and fixed, and, when placed on top of a mercury bath from which light was reflected, very true colours were reproduced. The results were excellent because the colours were exact replicas of the originals; they showed none of the deviations produced by the cruder, indirect simplifications of the three-colour dye processes. It was a direct process, but, with its cumbersome mercury bath and its long exposure, was not suitable for commercial application, and was not developed.

Also in 1891 Frederic Ives of Philadelphia, using Clerk Maxwell's findings, made a camera which could take the three required negatives on a single plate in a trefoil pattern of circles by means of a complicated system of reflectors, prisms, and filters of red, green, and blue. A positive on glass was made from the plate and was viewed through the eyepiece of a contraption Ives called the Photochromoscope. Like his camera, this also contained a system of reflectors, prisms and filters, which combined the images into one. Ives also produced the Lantern Photochromoscope which projected the three pictures first through red, green and blue filters and then through three lenses directed to form a single image on a screen. He improved his camera and a viewer, which in a new form he called the Kromscope. It revealed stereoscopic pictures in full colour and this he demonstrated in 1896 at the Royal Society of Arts in London to an astonished and delighted audience.

The Screen Plate

In 1893 the colour photograph which could be seen as a single entity was invented by John Joly of Dublin. This was the screen plate, an additive system forecast by du Hauron. Joly produced one negative instead of three, and his method of doing so was ingenious. He made a glass screen covered with many thin transparent lines in the three primary colours. These were ruled so close to one another at 250 lines to the inch that they could not be distinguished by the eye. The screen was placed in contact with a black-and-white photographic plate, and these were exposed in a camera in the ordinary way. The negative was developed and fixed, and a positive plate in black-and-white was printed from it by contact, being developed and fixed in its turn. The screen of ruled lines was next bound permanently in contact with the positive plate. The whole could then be projected as a lantern slide to reveal a picture in full colour.

The system worked in this way. During exposure varying amounts of light penetrated the screen of lines of the three primary colours on to the emulsion of the negative plate, where the tones of the colours would be represented in negative form after development. The tones were reversed to positive on the second plate, and, through carefully registering the tones with the original screen of coloured lines, a colour slide was produced. A white patch, for example, would be rendered black on the negative since lines of the three primaries would be represented on it in equal parts, and on the positive they would be returned to white through which the three colours of the screen could be projected. A red patch would admit light only through the red lines, and so on. This, of course, was another additive system.

A somewhat similar system, named microdispersal, was invented in 1895 by F. M. Lanchester. This had a grid of very

fine transparent lines. Each line served as a spectrograph slit passing light through lenses and a prism. So a series of tiny spectra were produced on the emulsion of the plate corresponding to the colours of the light from the subject. A positive transparency was made from the negative and placed in register with the grid. By projecting this through the original lenses and prism that had been used to take the subject, an excellent photograph was revealed in colour. But, like that of Lippmann, the system was too complicated for practical development.

Developments came in additive systems from Joly's screen plate. His lines were 0·1 mm. wide, and these produced a rather coarse result. The first commercially successful additive, single-plate colour transparency was patented by the Lumière brothers of France, the progenitors of the cinema. Their screen consisted of a filter of starch grains dyed red, green and blue, which were spread at random over, and compressed on to, the surface of the plate, the sizes of these grains measuring only 0·01 to 0·02 mm. in diameter. The plates were first marketed in 1907 under the name 'Autochromes' after the panchromatic emulsion had become available. The panchromatic emulsion was coated on to the screen and after development the plate was re-exposed to light and re-developed – the reversal process. The results were fairly good, but the plates were rather dark and the sensitivity of the plate was low because the grains and their opaque matrix of carbon black absorbed most of the light passing through the screen. Exposure time had to be some forty times longer than that required by a black-and-white photograph at that time. But the Autochrome was historically important as the first commercially successful colour system.

Other screen-plate systems followed the Autochrome such as the Dufay, the Agfa Autotype, and the Johnson or Finlay. The first, perfected by Louis Dufay in 1908, became popular. The screen of his plate was composed of a transparent grid, or *réseau*, of red lines between which lay squares coloured

alternately blue and green. In the Johnson process the screen was composed of a mosaic of red, blue and green squares.

All such additive processes, based on Clerk Maxwell's demonstration, have now been replaced by subtractive processes, both in films and printing papers, in the form of the integral tri-pack. One great advantage they have over the additive systems is that they do not absorb so much light; white, for example, is produced by complete lack of any *réseau* or colours, and in films it is completely transparent without any deposits. This means, of course, that exposures with subtractive systems can be far shorter than with additive ones and also that transparencies can be projected without an excessively powerful lamp behind them. Moreover, colour prints cannot be made by additive processes because the white areas are not clear. There is also a distinct graininess caused by their *réseau* when a transparency is enlarged.

Both additive and subtractive processes start in the same way with black-and-white negatives representing the tones of the three primaries in varying proportions. The additive transparency, however, contains not only a black-and-white positive image but also the mosaic screen, or *réseau*, of minute coloured filters of the three primaries, whereas in the subtractive transparency the three secondary colours are first coupled with three respective black-and-white negatives by chemical reagents, and then the black-and-white silver images are bleached, fixed, and washed away. Clearly, then, the subtractive is the more convenient in that it requires far less light to illuminate it.

The Modern Subtractive Film

A discovery which made the modern subtractive colour film possible was achieved in 1909 by Rudolf Fischer who found that para-phenylenediamine, when used to develop a black-and-white film, produces oxidation as it reduces the silver halides

to metallic silver, and that this oxidation can produce reactions in certain organic compounds incorporated in film emulsions during manufacture, turning them into insoluble dyes. The problem then remained of how to anchor the soluble colour formers to their respective emulsions during processing. The problem was complex, and the practical application of Fischer's discovery did not become possible for a quarter of a century.

The first subtractive film appeared on the market in 1935 as the 35 mm. Kodachrome, and this is still the most popular of colour films. It was followed in 1936 by Agfacolor, and, after that, by a number of other makes, notably Anscocolor, similar to Agfacolor and first produced in the U.S.A. in 1941. The chief difference between Kodachrome and Agfacolor is that the former is a type which has the colour couplers in the processing chemicals and so must be developed by the makers. Most films now have the colour couplers incorporated in the emulsions so that they can be processed either by the amateur himself at home or by the trade. The situation is somewhat complicated; although Agfacolor Reversal films can be processed by professionals, they are normally sent back to the manufacturers for processing, the cost being included in the price of the film. Agfacolor negative film, however, can be processed by the amateur like many other films.

The first subtractive negative colour film was produced by Agfa in 1939 and with it a new tri-pack printing paper, to create the world's first commercial negative-positive subtractive system of colour photography.

The dream of film manufacturers now is to combine the three emulsions into a single coating, and that may become possible before long.

Developments in Colour Printing

To complete this brief history something must be added about colour printing. The early prints were made by first exposing three black-and-white plates, one behind a red filter, one behind a green filter, and one behind a blue filter, to produce the so-called separation negatives. These could be taken in ordinary plate holders in a stand camera, but because slight movement of the camera when changing the plate holders was likely, special plate holders called 'repeating backs' were made which automatically exposed the three plates in turn, while the three filters were changed, also automatically, in front of the camera lens. This took several seconds, so that the subject had to be a still one. Later one-shot cameras were produced – developments of the Ives camera – which, by means of prisms, or half-silvered mirrors, inside the camera, could take the three negatives with a single instantaneous exposure. The three negatives were then printed on three sensitized pigment tissues – a yellow for the blue negative, a magenta for the green, and a cyan for the red. These were superimposed by transfer on each other in register to form the final print.

The earliest printing process of this kind, first introduced in the 1860s by du Hauron, was the carbon process. The prints were made with pigmented gelatine films in which fine carbon particles were dispersed and which were sensitized by immersion in a solution of bichromate. Three of these, having the three secondary colours complementary to the colours of the three filters used when exposing the separation negatives, were attached to a temporary support and exposed under the three negatives in turn to a powerful arc light. After exposure, those parts which had been obscured by the darker parts of the negatives and had not therefore been affected so much by the arc-light exposure remained soluble and could be washed away

in warm water, while the light parts which had been hardened by the light remained. Thus three positive relief images in hardened gelatine were produced. Finally the three images were transferred to a gelatine-coated paper one after the other in register. The system was complicated, and the description is over-simplified.

This carbon process was so insensitive to light that enlargements could not be made. An improved and modified method came with a process devised by T. Manly under the name 'Ozobrome' and developed by H. F. Farmer as the 'Trichrome Carbro'. Here the bichromate did not serve as a sensitizer but as an agent used on bromide prints in contact with pigmented gelatine tissues. This process was also complicated and involved double transfer so that the final image appeared the wrong way round.

Both the carbon and the carbro methods used relief images on gelatine. In the carbro method, each of the three prints was laid in contact with one of the three gelatine tissues and bleached; the bleaching hardened the gelatine to degrees which varied according to the tones on each print and so the gelatine which remained soft, because more or less unaffected by the light, could be washed away to produce the relief image. (Hence one name for the process was 'Wash-off Relief'.) The three relief images of the tissues were finally printed in register on white paper. When skilfully handled the resulting print was excellent for a good deal of control was possible by modifying the three prints before making the tissues.

Neither the carbon nor carbro methods are in use today. Most colour prints are now made on tri-pack papers from colour films, both negative and reversal. These papers are of similar constitution to the tri-pack films and have made colour printing comparatively simple. The difficult job of achieving precise register of the three images is avoided – a job which becomes almost impossible in very large prints owing to the

uneven and unequal stretching of the reliefs. But trichrome carbro prints could be very beautiful and aesthetically the tri-pack print is not an improvement. The final phase of trichrome carbro was available until a few years ago as the Autotype trichromatic pigment papers. Now even these are off the market.

The Kodak Dye Transfer system, which first appeared in 1934, still survives as a development of relief printing. Here either separation negatives or a tri-pack negative film can be used. The separation negatives can be produced separately, either by exposure in a camera in the old way or in the darkroom from a positive transparency. Three gelatine relief images are made, the hardening being accomplished by a special developer. A good deal of hand-tailoring to adjust colours is possible in making these images. The three reliefs, or matrices, are dipped respectively in special yellow, magenta, and cyan dyes, absorbing varying amounts of dye according to the thickness of the gelatine at each point. The reliefs are then pressed in turn on a gelatine-coated paper with a squeegee in exact register. An advantage of the system is that up to a hundred prints can be made from the same set of reliefs, but skill and practice are needed to achieve good results, and it is costly done by the trade, owing to the skill and time required. But the best prints are now made by this system, and it is still used extensively by professionals. Tri-pack prints cannot be washed quite free of chemicals and these affect the stability of the colours. Dye transfers, however, are free of these impurities; moreover dyes can be used which are more stable in themselves and fade less. The latest simplification of Dye Transfer uses a tri-pack negative film instead of the three separation negatives; then the three reliefs are made directly from the negative by exposing them in turn through red, blue, and green filters.

Apart from Kodak Dye Transfer printing, all modern colour photography, both in films and prints, is based on the integral

tri-pack subtractive system. With the negative colour film combined with the companion material of tri-pack paper, we have reached a fairly simple situation. Further simplification, notably in processing, is likely to come soon together with other improvements such as greater stability of colours.

The latest and most remarkable development in colour printing, first marketed in 1963, is the colour print produced automatically in the Polaroid Land Camera. Polacolor is an American development of Dr Edwin Land's original black-and-white 'pictures-in-a-minute' invention and it became possible only after many years of intensive research. In practised hands, the making of an ordinary colour print now requires about fifty-one minutes to process the negative and then forty-two minutes to make a print from the negative – over an hour and a half. With the Land camera and its special film you can, without any skill at all, make an exposure, pull a tab, wait about sixty seconds and then lift a finished colour print from the back of the camera. The method by which this is achieved is complex, and, while its chemistry remains a secret, it is otherwise fully explained in *Instant Pictures: The Complete Polaroid Land Camera Guide* by John Dickson (Pelham Books).

Chapter 3 | *What is Creative Photography?*

First, what is a work of art, in colour photography or any other medium? Why does it give pleasure, or at least provide a vitalizing and cathartic stimulus? Philosophers are still arguing about it. Here we can only grope for the answer, but, since we are discussing photography as creation, we must make a bold, if brief and inadequate, attempt to find it.

Defining Art

Many definitions have been tried. One is that art is 'the production of beauty for the purpose of giving pleasure', another that it is 'emotion cultivating good form', a third that it is 'significant form', a fourth that it is 'that which, having been intentionally created, is capable of producing the sentiment or impression aimed at by the artist in all persons able to respond to such sentiments or impressions'. William Morris thought that 'anything that you take pleasure in doing is art', while Sir Herbert Read has written well that an artist is 'a man who by his special gifts has solved our emotional problems for us'.

None of these definitions takes us far and most of them beg the question. To be an artist is surely not merely to be a painter or sculptor, nor even to grow a beard. It is rather to hold a certain attitude of mind towards life and work. An artist regards his work as an intense form of play; he tries to express himself as a unique individual in whatever sphere of activity he may have chosen – as a free and dedicated being. A sales director, a circus performer, a publican, even a criminal, can

in that sense be an artist. Aesthetics are not obviously and directly linked with ethics as some philosophers, including Tolstoy, have claimed, although in the final analysis they may be so if we regard the ultimate end of moral behaviour to be life-preservation and life-enhancement and so connected with the attainment of psycho-physical and social well-being. Individual health in its widest sense is far more complex than many doctors may believe, for it has much to do with a whole social-economic situation. Well, all things linked are, but it seems that every effort to produce a work of art is the affirmation in symbolism that, in spite of all its pain and certain death at the end of the road, living is incontestably desirable. To be more obscure, perhaps a work of art is a symbol of Natural Selection, of Ecological Balance, of the Life Force.

Any work of art, be it, for instance, in writing, music, drama, dancing, painting, sculpture, architecture, photography – or more indirectly perhaps as craft in cooking, furniture design, boat building, gardening, human relationships – is a unity in multiplicity from which nothing can be taken away and to which nothing can be added without destroying it. It is complete. An artist is one who finishes a job, and his creation achieves a wholeness which means more than the sum of its parts.

Yet wholeness is not enough; a black circle on white paper is whole but it is not likely to be a work of art. A creation must contain the diversity, complexity, contrast, and tension of life itself, but unlike the inconsequential muddle and chanciness of life, it must have a controlled and purposive unity of design. And this can only be produced by a single personality. As Sir Christopher Wren declared, 'Variety in uniformities makes compleat beauty.'*

Perhaps the value of a work of art lies in its serving as a

* This has been expressed by modern aestheticians in the formula $M = O \times C$, where M is Measure of aesthetic value, O is degree of unified Order and C is degree of Complexity.

symbol of the power of a personal human control over destiny, and so of the resolution of that conflict for which every living thing at every level of evolution is striving, both within itself and between itself and the changing environment – a symbol of the removal of frustrations and the satisfaction, even exaltation, which comes from having stabilized emotional tensions in a symbolic form. 'The artist is a man who has solved our emotional problems for us.'

. But a work of art can also be a protest – possibly a social protest, or, more widely, a protest against decay and the remorseless movement of time, through the expression of permanence and stability. (Even Dadaism, Art-anti-art and Self-destructive Art may be making this kind of protest by means of a peculiar and desperate paradox.) As Shakespeare tells the young hero he addresses in the Sonnets:

> So long as men can breathe, or eyes can see,
> So long lives this, and this gives life to thee.

Artists are often at odds both with themselves and with the world. Being rebels and sensualists, they and their works are often feared as tending to disrupt those emotional repressions and vested interests of the puritanical *status quo*, which are both necessary to the survival of a social organization and its culture and yet contain the germs of its disintegration – as Freud pointed out in his remarkable work, *Civilization and its Discontents*. (The meaning of art seems to have baffled Freud. If he had delved into the aesthetic mysteries, he might have written one of the world's great books.) Yet the artist is striving, often desperately, towards order by expressing this in visual or other sensual symbols. He instinctively knows the truth of Norman Douglas's angry comment, 'The antagonism of flesh and spirit is the most pernicious piece of crooked thinking that has ever oozed out of our deluded brains.' So in a work of art, Dionysus, god of libidinal excess, and Apollo, god of form and order, achieve a temporary truce.

In short, art harmonizes tensions and in so doing represents abundant life. In that sense, it is functional. In the words of a Chinese saying, 'If both Equilibrium and Harmony exist everything will occupy its proper place and all things will be nourished and flourish.'

But you may say that great works of art often present images of disturbing horror (Goya, Bacon). Maybe, but in themselves and in spite of their subject matter, they are finally harmonious, and in being so they make their protest the more powerful and humane. Art is not always pretty, lyrical, or even beautiful (a hard word to define). Horror can produce the purging poetry of shock.

The painter Mondrian said that 'art will disappear as life gains more equilibrium'. But when will perfect equilibrium in life be possible? Life will always be imperfect, even when all poverty and toil have been removed in the most perfect, and therefore anarchic, society. Art is a tonic in an unsatisfactory world. It takes us out of ourselves. It may also be a symbolic surrogate for the ego's sense of isolation, of alienation, of guilt, which at its most acute can turn to madness. Perhaps it is a compensation for what we lost so long ago – the primeval sense of being at one, not only with tribe or family but with the whole of nature – an antidote to the schizophrenia inherent in every complex civilization, to the unresolved conflict between thought and feeling, and so between man and man, and between a man and himself.

Originally, as in the cave paintings of pre-history, art was directly concerned with fertility ritual, not least with hunting, and thus with survival. It was sympathetic magic. Its function was economic and social, and it was not deliberately concerned with creating beauty. The magical element in the art of more developed cultures is less obvious; the economic ties are longer and more ravelled, but they surely exist.

In time the sorcerer, the witch doctor, became the priest,

doctor, scientist, thinker, poet and artist. Even today the artist who achieves wide recognition is still regarded to some extent as a sorcerer, a worker of wonders. Picasso, for example, has only to make a scribble on a hat to invest the hat with a mystical (and monetary) potency which is beyond rational explanation.

Art has become a kind of therapy, and so, in a way, it is still concerned with survival. It seems so necessary to the existence of any culture in its widest sense as a social-economic structure, that we have come to apply the word culture in the more limited sense of artistic expression. If the individual is thwarted of self-expression and its communication to others, whether in a fine or an applied art, his energies turn to brutal aggression. Even when apparently protestant, art is therefore an antiseptic to disruption, and there is little doubt that the appalling destructiveness of our own times is caused largely by the frustrating of the individual's creative impulses by subtle monetary methods of enslavement which are as yet barely acknowledged to exist at all in any country although quite inappropriate to this new age of technology.

All this may seem to be pretentious talk to the reader who only wants to learn how to take a few colour snapshots as competently as possible in his limited hours of leisure. Yet this brief attempt to clarify general aesthetic aims may be of some value to the devoted enthusiast, who is trying to express his desire and pursuit of the whole. We must make some attempt to understand our purpose.

Some claim that the creative side of photography lies not at all in its straight application but in contrived and technical tricks of every sort. It can lie there, no doubt, since all techniques which use the action of light on photosensitive materials may be regarded as legitimate photography. But selective composing to create a viable unity, a wholeness, is surely the foundation of creative photography, whether the approach is contrived or direct.

Composing

What are the classical canons for composing a unity? The keys
are: Contrast, Rhythmic Repetition, Climax, Balance, and
Cohesive Simplicity. These are the elements which help to
harmonize tensions and so produce wholeness, whether in a
play, or a symphony, a poem or a building, a painting, or a
photograph. Yet a work of art cannot be achieved merely by
learning and applying a few rules. As Ruskin remarked, 'If it
were possible to compose pictures by rule, Titian and Veronese
would be ordinary men.' Or, as Jean Cocteau commented dir-
ectly about photography:

> A true photographer is as rare as a true poet or a true painter. The
> camera lens is a glass eye with no more worth than any other stupid
> eye unless it transforms what it sees. And I do not mean angles or
> compositions, but the phenomenon which enables the photographer,
> by the intermediary of a machine, to consummate the strange wedlock
> between the conscious and the unconscious, of which the delicious
> monstrosities of poetry are the issue.

Yet rules may be helpful to start you off. Thereafter you are
on your own. Then let thinking cease to dominate and let feel-
ing take over.

Contrast produces vitality. In a photograph it may appear as
complementary colours, as light and dark, curved lines and
straight, close objects and distant ones, vertical forms and
horizontal ones, roughness and smoothness, plain areas and
decorated ones, void and solid.

Rhythmic Repetition of certain shapes and elements will help
to produce unity, like the beat in music: vertical boles in a
woodland, windows in a building, the heads in a crowd.

Climax is the focus of a picture, the centre of interest around
which other elements revolve and to which they are subservient.
The lines in the composition may run towards this dominant
feature which will be like the most dramatic moment in a play,

or the main entrance of a building. It may not be immediately obvious but it will exist in every strong composition. Curiously enough, its strongest and most interesting place will never be at the precise centre; the nearer the edge of a picture it is the more powerful it will become.

Balance is an equilibrium of weights of interest, so that the whole will not seem to tip to one side or the other. Just as we like to feel balanced on our two feet, so do we like to feel that a composition is in balance. If the climax, or focus, is well to one side it will require an equalizing element or elements on the other side. The achievement of this balance is entirely a matter of intuition; tones, shapes, colours and their meanings will all have their effects.

Cohesive Simplicity depends not only on contrast, rhythm, climax and balance but on something more: the inter-relationship of parts with one another and with the whole. Often this is achieved by half-sensed geometrical forms. I have seen a painting by the elder Bruegel of two woodcutters which, for some reason I could not immediately understand, had a remarkably strong cohesion. Then I suddenly saw that the whole structure was based on a series of circles. Many firm compositions are based on such geometrical forms, whether the circle, ellipse, cross, S-shape, L-shape, square or rectangle. But cohesion depends on more than formal structure; it depends on the binding idea which the whole intends to express. Cohesive simplicity should be the final aim of any composition. It is the most difficult thing to achieve. The more simple a composition is the more subtly and finely adjusted it must be. It is the unification of complexity.

One cannot too often repeat that in colour photography this simplicity is most readily achieved either in the close-up or in the restricted angle of view, for then intrusions and irrelevancies are more easily avoided and colours tend to unite as well as forms.

Just as the silences are as important in music as the sounds, so in a picture what you leave out is as important as what you include. As Michelangelo explained in his famous reply when asked how he produced his great works of sculpture, 'I take a block of marble and knock away all that is unimportant.' More often than not, part of an object selected to make a picture can express far more, and with greater impact and force, than the inclusion of the whole object.

Here are a few more random hints on composing. First, never as a working rule create an unresolved duality by, for example, making a straight line divide a picture into two equal parts – or by creating two focal points of equal and competing interest – or by trying to make more than one comment in a single picture. On the other hand, always be wary of dogma; you may, in fact, need a duality in order to express the tension between two interests.

Creating the illusion of three-dimensional depth on the flat surface of a photograph can be dramatically effective, particularly by the inclusion of a very close foreground object. This need not be in sharp focus, and it may well serve as a balance to the distant climax of the picture.

Asymmetrical composition is generally more interesting than a completely balanced symmetrical one. But again beware of dogma. If you are photographing a monumental scene, perhaps a royal ceremony or a grand baroque palace, a monumental symmetry may be necessary to the theme. Symmetrical composition in a portrait is rarely satisfactory, and tends to be either dull or to look like a police record. On the other hand, certain tidy personalities may best be expressed by symmetry.

Do not allow too many lines to run out of the picture. The line of a horizon can be contained by small vertical objects at the ends, such as a distant tree or spire. And to avoid duality do not allow the horizon to divide the picture into two exactly equal parts.

Forms have their symbolism. Horizontality suggests repose like a sleeping body. Verticality suggests dynamic purpose. Rounded forms and curving lines suggest protective femininity and emotional subtlety, while straight lines, rectangles and angularity suggest masculine purpose and intellect.

Scale may be important to give a feeling of size. For example, a mountain landscape may be vast but no feeling of this grandeur may be apparent in a picture unless it contains some object of recognizable size – a cluster of roofs or a tiny human figure. Small objects contrasting with large ones of the same shape will give a sense of great size, such as a row of small arches contrasting with one or more arches of huge proportions.

But never be ruled by rules. Like technique, composition is, after all, not an end but a means. The end is expression – the personal comment on something which moves you in some way, even if that is the most sophisticated expression of love for purely abstract forms and patterns. It is hard to say where expression and composition separate; they are so closely connected. Some believe that composition is unimportant, or at least that one should not consciously strive for it. Yet composition always exists in a work of merit however subtly it may be concealed in the apparently casual doodling. Photography may have been partly responsible for producing this apparent casualness in painting. Eliot Elisofon makes an interesting comment in his book, *Colour Photography*, which is relevant here:

Colour composition – and this applies both to photography and painting – is always a question of design, the arrangement of masses and lines within a given area to produce an effect. This choice of effect must be dictated by the purpose of the picture. If serenity, for example, is the goal, the elements in the picture must be perfectly balanced and produce a quiet, restful composition. If the dynamic approach is the aim, diagonal lines and unequal masses are needed to set up action in the composition. The old rules that the sky must make one-third of the composition, or that the top of the picture

must never cut off a head in a portrait, are broken continually. Photography, in fact, helped to change the classic rules of composition when painters fell in love with the accidental compositions produced in snapshots. Degas, for example, who was an avid amateur photographer, cut ballet girls in half at the edge of his photographs, or even at the top, and as a result did the same thing in his paintings. ... Another painter influenced in this way was Toulouse-Lautrec. Classic composition is still a good beginning for any artist. You should know the rules before you break them.

After all, composing in any medium is the expression of emotion by the discipline of ordered relationships. It is the battle against chaos. The famous French photographer, Henri Cartier-Bresson – a masterly composer – has offered some helpful words:

Photography is to me the simultaneous recognition, in a fraction of a second, of the significance of the event as well as of a precise formal organization which brings that event to life. ... This visual organization must come from an *intuitive* feeling for plastic rhythms, which is the backbone of the arts. Composition must be one of our *constant* preoccupations right up to the moment a picture is about to be taken – and then feeling takes over.

We have discussed that special virtue of creative photography to select and frame a significant and unified part of the world. Its other virtue is its power to capture movement and freeze for ever an event which happens in an instant and will never recur. This may be nothing but reportage, journalistic recording, but the sensitive eye can use a passing event to create a formal composition of great fascination. The interest of a subject may be good journalism, but it will not alone make a creative photograph. As Théophile Gautier wrote, 'When a fresco or picture does not give you pleasure independently of the idea and the subject it represents, the artist has failed in his purpose.'

61

Perhaps no photographer has been so adept at giving this kind of pleasure as Cartier-Bresson in his black-and-white pictures. To quote him again, 'For me the content of a photograph cannot be separated from the form, and by form I mean a rigorous plastic organization through which our conceptions and emotions become concrete and transmissible.'

Let the sensible words of the distinguished painter John Piper, who is also a fine photographer, conclude this chapter:

There must be that relationship between the man with the camera and his subject which allows him to see it for a moment, as it flies, as nobody has ever seen it before or will ever see it again. And there is no doubt that every single one of us has an individual vision, if we allow ourselves to find it and explore it. The way to get at it seems to me to be to ask oneself not 'now how can I take a good photograph?' but 'what do I like enough to make me want to photograph it?'

Chapter 4 | *Colour Theory*

In composing colours rules again exist to be broken if intuition feels it knows better than reason. But again a few rules may be helpful as a starting guide. Can a clear distinction really be made between good taste and bad in colour choices or in any other form of designing? What pleases one person may not please another, and who is to judge what makes a 'good' colour scheme, whether applied to a colour photograph, a painting, a room, or any other design. Moreover, tastes change with the fashions and from one generation to another. Yet I believe that certain timeless standards exist.

Harmony in Colour

In the end good taste probably arises from a reliance on natural physiological reactions rather than from education and tradition. That is to say, to the sensitive eye, colours having certain vibrations or wavelengths will blend harmoniously in almost a mathematical sense (as sound harmonics do), while others will not. Thus, just as with sounds, we can make either a meaningless noise with colours or we can make music.

Like sounds, colours are distinguishable because they possess different wavelengths. The connexion between colours and sounds in this respect has been studied, notably in a comparison between the musical octave and the seven colours of the spectrum, sharps and flats being represented by appropriate shifts of colour along the spectral band. It was found that music can be transposed into colours by keeping the mathematical

intervals the same so that harmonious chords produce their equivalent harmonies in colours. Major and minor moods can also be transposed into colours in this way.

This does not mean that only harmonies make music. Too much harmony without the occasional discord becomes over-sweet, insipid, or dull. What is needed is deliberately to select the harmonies and the contrasting discords, both in music and colour composing to make your complete pattern, your vital, expressive unity. Since all discord would be far worse than all harmony, discords should be used only to make one appreciate the harmonies the more through contrast.

When you take to colour photography after black-and-white you have to see in a different way, for colours convey their own emotional messages – their own music. What may make a fine black-and-white subject may be meaningless or trivial in colour, and vice versa. No photograph is necessarily improved only because it gains colour; the colour must have meaning in itself and dictate the composition. In this, 'truth to nature' is aestheti-cally irrelevant; it may even be a hindrance to expression.

The Mystery and Meaning of Colour

In the whole mystery of sight, that of colour consciousness is the least explicable. The strange thing about it is that, like the grin without the cat, it does not really exist except subjectively in our minds – not something we see, but a way of seeing. We may have some notion of how the eye works in its complexity of nerves and other parts, and we may be able to measure and label light of different wavelengths which affect the eye, but this does not explain why we see colours as colours.

For thousands of years enquiring minds have been trying to explain the mystery – Plato, Diogenes and Aristotle among them – but, in spite of our rapidly growing knowledge, the mystery remains. We do know, however, that colour has always

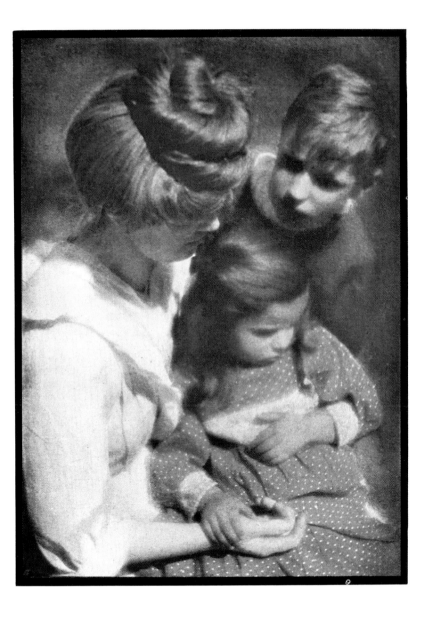

1. Heinrich Kühn: *Portrait Group* (Autochrome, 1908)

2. Stefan Buzas: *Sicilian Bride*

3. Norman Parkinson: *Princess Anne at 21*

4. Fred Mayer: *Scottish Mountains*

5. Ray Moore: *Landscape with Ruin*

6. Ernst Haas: *Abalone Shell*

7. Alfred Lammer: *Ribbed Hosta Leaf*

8. Augustus Lunn: *Microphoto of a Holly Leaf*

been of great practical use and that it has helped the human race to survive. It is fundamentally functional. Margaret Mead pointed out that Eskimos have not one word for white but seventeen; with these they can communicate the different snow conditions which affect their hazardous lives. In our very different culture we use red, green and amber, for example, for traffic lights to reduce congestion and death on the roads, and water taps are marked in red for hot and blue for cold.

Some primitive cultures have no words at all for colours. The Bible apparently refers to the sky or to heaven more than forty times, but it never once mentions the word blue. Even in our colour-conscious age we still use words for colours in very loose ways.

Because of its biological value to us through the ages, colours produce emotional reactions by association; they can thus be used to communicate feeling through visual expression. But do we all see colours in the same ways as one another if we have normal vision? How can we ever know? Clearly the effect of different colours on our feelings is to some degree personal, on account of the memories, experiences, prejudices and preferences we gather through our lives; a moving or traumatic experience may occur under certain conditions of colouring, that of the walls of a room or the dress of a loved one at a first meeting, so that thereafter those colours will to some degree reproduce the original emotion, whether consciously or not.

Nevertheless, different colours obviously have certain meanings which are universally accepted. How can red and orange be anything but warm, as fire is warm, or green and blue be anything but cool, as woods and lakes are cool? Colours can convey moods to us all – of conflict or tranquillity, sadness or gaiety, warmth or coolness. They can whisper or shout, be male or female, tender or brutal, sweet or sour, boring or stimulating. We all know what is meant by 'seeing red' or

'feeling blue', just as people did in the past when they spoke of 'choleric red' and 'melancholy blue'.

So powerful, indeed, is the emotive content of colour that it can affect health. We are only beginning to understand the virtues of colour therapy, although it has been applied for some time. Pythagoras and Galen practised it, and so did the Arabian physician Avicenna. All through the ages men have used colours not merely in practical ways but in emotional and social ways too: to distinguish castes and professions in dress, in magical and sacred rites, in witchcraft, and in medicine.

The order of preference among Western people is said by some to be: blue, red, green, purple, orange and yellow. Others say the order is: red, blue, violet, green, orange and yellow. Pure colours, at least in small areas, are preferred on the whole to intermediate tints. Such preferences may be partly timeless and immutable, but they are as likely to be conditioned by cultural situations, for every period has its preferences for certain colours and their combinations.

Designating Colours

At present we have only a few colour names in frequent use: red, pink, orange, yellow, green, blue, purple, violet, mauve and brown. Yet the normal eye can distinguish no less than a million different colours if they are placed side by side, and under the best possible lighting conditions it can distinguish ten million. We cannot name them all, but some system of designating colours more precisely and fully than by the words of everyday speech has become necessary; we can, at least, number hundreds of them. Several such colour systems have been devised to provide an exact notation of colours in their varying hues, purities, mixtures, and shades. The Ostwald system is a famous one, but that now in most general use was invented by Albert Munsell (1856–1918), a Boston artist and teacher. His

system, started in 1912, and adopted by the American Standards Association in 1942, enables hundreds of colours to be precisely specified, and rapidly and clearly communicated. Notated colour samples can be selected in composing colour schemes for any purpose either from published charts or from special cabinets containing the samples. Three-dimensional colour models, or 'trees', can be constructed, having their central axis as a scale of grey values from white through darkening shades of grey down to black, horizontal circular bands as different hues, and paths running outwards from the axis as steps of saturation.

Colours in the Munsell system are specified in terms of visual sensation by their degrees of Hue, Value and Chroma. Hue is the dominant spectral wavelength – the colour itself; Value is the brightness or luminosity – the difference, for example, between light red and dark red; Chroma is the purity or intensity of a colour between the fullest possible saturation and neutral grey. Thus $R\frac{5}{8}$ would represent the hue of red with a value of 5 and a chroma of 8. Whole colour theories of harmony, contrast and discord can be worked out by these Munsell notations. The system is a most useful one in many ways. It may not be directly of much use to the colour photographer, but it can be very helpful to the student of general colour designing as a means of experiment by trial and error, and also in the working out of colour theories.

Analysing Colours

Let us now analyse the emotional meanings and symbolism of the colours in the broad and over-simple designations of daily speech in their spectral order, on the understanding that they are never seen in absolutely pure forms, and rarely alone.

Red is the most positive of colours, the most violent, aggressive and exciting. It attracts the eye more strongly than any

67

other. It was the first colour to have been given a name in early languages, and it has been used more often than any other in primitive art. The word red is one of the three colour names which occur among the 500 most frequently used words in the English language, the other two being black and white. (14 colour names in all occur in the first 1,000 words.) As everyone knows, red stands for danger, perhaps because it is not only alerting but penetrates mist better than other colours. It is also associated with warfare; the battle flags of the Roman legions were red, and we have had scarlet soldiers' tunics for centuries. It is also associated with revolutionary ardour as in the Red Flag, and even the kindly members of the Salvation Army know the rousing force of their strange slogan: *Blood and Fire*.

Orange is nearly as eye-catching as red. It is an aggressive colour and grows irritating in large quantities. But obviously it is warm and cheerful, being associated with flames. It seems to have far fewer and less definite and traditional associations than red.

Yellow is also less definite in its symbolism than red. While it is the most luminous, sunny and cheerful of colours, it is, strangely enough, the least popular, perhaps because it is associated with cowardice, jealousy, deceit and disease. Yet it was fashionable among aesthetes in the 'Yellow Nineties', it has signified divine glory, and it was for centuries a sacred colour in China; the robes of Buddhist priests are yellow. Van Gogh applied yellow in his painting of the night café to express, as he wrote in a letter to his brother Theo, 'the powers of darkness', and to create an atmosphere 'like a devil's furnace', a place 'where one can ruin oneself, run mad or commit a crime'. But he chose a sulphurous yellow. Perhaps the symbolism of yellow is confused because it has a number of distinct shades and even in common language it really needs not one word but at least two; the lovely warm yellow of ripening

wheat would not have done for Van Gogh's café painting in which the yellow contains much green.

Green brings us to the cool part of the spectrum. It is calm, contemplative, vegetative and refreshing. Indeed, the word comes from the Aryan *ghra*, meaning to grow (hence presumably the word agriculture). It symbolizes immortality, freshness and peace (olive branch), but it can also represent immaturity and envy. In some hues and contexts it becomes sinister and associated with cadaverous sickness, especially when mixed with yellow.

Blue, especially green-blue, is the coolest, least sensual, most reserved, quiet, serene and aloof of colours, associated with the remoteness of distant mountains and 'the serene irony of the eternal azure' (Mallarmé). But it can contain a depressed note and can be heartless as ice. At its richest it is maternal, protective and soothing.

Violet and **Indigo** are neither warm nor cold. As Goethe wrote, pale hues of violet 'tend to give an uneasy, soft, yearning feeling'. These are somewhat negative, shy and resigned colours, but among the right companions they can reveal charm. When dark they are sad and solemn, associated with old age and even death. In religion they denote penitence and celibacy. They were as temporarily popular as yellow in late Victorian times, partly perhaps because the age was dominated by the mournful personality of the widowed queen, who favoured the colour.

Purple is not contained in the spectrum for it is obtained by mixing violet with red. Here is a grand, stately, noble, even pompous colour, the colour of majesty. The ancient Tyrian purple, so rare and costly, was used to dye the robes of Roman emperors. Though having far more courage and vitality than violet, it is also associated with death, and some psychiatrists believe that extensive use of violets and purples by an artist shows his unconscious anticipation of dying. Christ, it is

believed, wore purple clothes at his crucifixion, and Homer used the name to denote sadness and extinction.

White, which is all the colours, is delicate yet obviously positive, clean, cheerful and airy. In the West the bride goes in white, yet in China, strangely enough, white is used for clothes of mourning.

Black, which is no colour, is deeply nihilistic. In the West it stands for oblivion. Combined with white, it can be smart, and it is as vitalizing as white when used as a foil to full colours.

Grey, which both absorbs and reflects all the colours, can be either cheerful if near to white or gloomy as it approaches black, but on the average it is merely humble and sedate. Of course it makes a splendid neutral foil to enhance the brilliance of other colours.

Combining Colours

We now come to the complex question of combined colours. That is how we mostly see and photograph them. Colours affect each other profoundly, to such an extent that the emotional impact of a single one may be completely changed by those surrounding it. Every single area of colour in a picture affects all the other areas of colours; all are interdependent; everything is relative. We must see all the parts as a telling whole, as an organization.

To take a simple case, a colour will seem the more brilliant and pure against its complementary than against any other colour, and so it will also against a neutral grey. A saturated red will seem to contain some blue when surrounded by yellow and some yellow if surrounded by blue, but, the less saturated colours become, the less do they effect each other in this way. Dark tones and debased colours will seem darker by contrast against light tones and desaturated colours, and vice versa, while spots of neutral grey on a saturated background will

seem to take on some of the colour complementary to that of the background.

Ruskin wrote:

While form is absolute, so that you can say at the moment you draw a line that it is either right or wrong, colour is wholly *relative*. Every hue throughout your work is altered by every touch that you add in other places; so that what was warm a minute ago, becomes cold when you have put a hotter colour in another place, and what was in harmony when you left it, becomes discordant as you set other colours beside it; so that every touch must be laid, not with a view to its effect at the time, but with a view to its effect in futurity.

Although Ruskin was writing about painting, his words do stress the fundamental effects colours have on one another in any colour scheme. 'There's no blue without yellow and orange', said Van Gogh, that superb and courageous colourist. Degas claimed that if he had only dingy mud with which to paint he could turn it into the purest colours simply by subtle juxtapositions.

The Colour Circle

Before discussing how colours affect each other, let us draw a Colour Circle, based on Munsell, by bending the colours of the spectrum so that the red end comes close to the violet end. The colour linking red and violet will be a mixture of the two in the form of purple or magenta, a colour which does not appear in the spectrum.

This diagram is purely graphic, and each colour will in reality merge gradually into the next one in infinite gradations. The main part of the circle consists of twelve fully saturated hues, which contain neither black nor white. Running through this are the greyed colours containing both black and white. Outside the main circle is a range in which black is added to the saturated colours and the outer rim of this will be pure black.

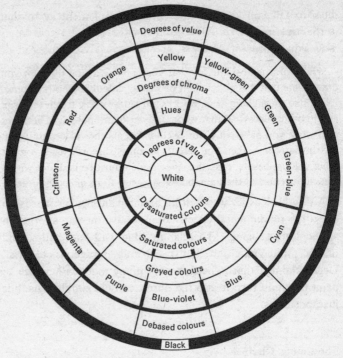

These are the Debased colours. Inside the main circle is the range in which white is added to the saturated colours, and the inner disc will be pure white. These are the Desaturated colours, the pastel shades.

A colour can therefore vary in black content, in white content, or in black and white, that is greyed, content. No other kinds of colours exist. (In the terms of the Munsell System, degrees of Chroma are represented by the greyed circle, Hue is represented by the main circle of the fully saturated colours, while Value is represented by both the outer or Debased, and the inner, or Desaturated, circles.)

As already noted, the eye can distinguish up to ten million different colours; it can also, it is said, distinguish up to three

hundred in the spectrum itself. Yet only six distinct colour sensations exist: whiteness and blackness in the achromatic scale, and redness, blueness, greenness and yellowness in the chromatic. These six do not resemble each other in any way, and every other colour can be described in terms of them. For example, in orange we see both yellow and red, in purple both blue and red, and in grey both black and white.

In the Colour Circle the warm and active colours are opposite the cool and passive ones, and complementaries are opposite one another – red opposite cyan, green opposite magenta, blue-violet opposite yellow. The maximum colour contrast to any colour is the one diametrically opposite in the circle and therefore called complementary because, as we have seen, together they make white light. Minimum contrast is produced by neighbouring colours, and colours anywhere in the circle which are near each other provide a harmonious key; that is to say, local areas in the complete circle will provide the most simple harmonies; the closer they are, of course, the more similar they are, such as greens, blue-greens and blues. Provided they are of the same degree of saturation (the Munsell Value) complementary colours, such as red and cyan, do harmonize while also providing the vitality of contrast and an enhancement of each other's brilliance. The more saturated they are, the more vitality, possibly even crudity, they will have, whereas desaturated, degraded or greyed complementaries will lie more quietly together.

Some complementaries do not harmonize well if one is degraded and the other desaturated. For example, pale green and dark magenta do not like one another, nor do dark orange and pale cyan. Nor do some colours touching each other on the Colour Circle always harmonize if their saturation differs. For example, pale blue and dark green combine less happily than dark blue and pale green. A general rule seems to apply here: whereas most of the saturated colours can tolerate each other,

if we desaturate the colours increasingly from full yellow, the lightest in tone of the hues, round clockwise to orange, each colour becoming more desaturated in turn, we obtain a circle of displeasing colours however we may join them. The same applies to the outer debased circle and the inner desaturated circle too. But, to repeat yet again, all rules exist to be broken, and disharmony produced by mixing such colours may be necessary in a composition to provide an acid touch. In any case, as already stressed, so much depends on the relationships and areas of the whole picture. Colour relationships are so infinitely great in numbers and subtleties that colour theories can serve only as rough and ready initiating guides.

Some Practical Points

Note several points: the eye will tend to grow weary of an overall, dominant colour and will desire a balancing stimulus from its complementary. So if you have a dominant blue-green in a picture, a touch of red will have a vitalizing effect, and seem more brilliant by contrast. A landscape containing nothing but greens calls out for a complementary touch – say of russet or deep indigo. If both blue-green and red exist in equal quantities in a picture, a distressing duality of interest may be caused and neither colour will seem particularly brilliant. If blue-green and red are spread in small areas all over a picture, the general effect, at least at a distance, will be merely one of dull grey.

All colours, especially when saturated, appear at their brightest against a grey background. A red is particularly rich against a background of neutral grey. If a tinge of the complementary colour of blue-green is added to the whole grey background, making it a highly desaturated colour, vitality will be gained and it will also produce a curious phenomenon: a sense of three-dimensional depth.

This effect of colour perspective must be understood by colour photographers as well as by painters. It has a physiological cause in that the eye is not fully colour corrected in the way that all modern camera lenses are. This means that, having different wavelengths, the rays which produce the sensations of different colours do not all fall into exact focus at the same time at the back of the eye; a minute muscular adjustment of the eye is needed to change the focus from a clear vision of a red or orange object, for example, to that of a green or blue object on the same plane. The eye has to focus at a slightly shorter distance for reds and yellows than for blues and greens when they are at the same distance from the eye. This phenomenon explains why highly saturated, complementary colours often appear to vibrate uncomfortably if one is imposed on the other, particularly red on blue-green, for the eye tries to adjust itself to both wavelengths at once by rapid oscillations. This means that complementaries must be treated with care if touching, or imposed upon, one another at high saturations.

So red and orange will seem to stand out from a background of green or blue, and will dominate a composition for this reason, quite apart from their being the most dominant of hues. Thus a portrait in which clothes are green or blue is inadvisable against a red background. Pale blue-green, however, is particularly suitable as a background for close-up portraits where the flesh colours are pink and so complementary to the background colour. As a working rule, keep the cooler colours in the background and the warmer ones in the foreground; this will always increase the sense of depth.

Red can be used as a frame if the aim is to increase the sense of depth inside that frame, but reds must always be handled with care because they are so assertive. Reserve them mostly for the focus, or centre of interest, and use them in small areas. They will have more power that way. They should be used with much caution in out-of-focus backgrounds for then their

distraction is not softened but increased, because the size of their areas is increased, while surrounding shadowed areas, which when in focus would tend to neutralize the reds, are reduced in force.

Just as warm colours advance and cool ones recede, so do light tones advance and dark tones recede, and this effect can also be used to increase a sense of depth. A pale yellow would thus stand out sharply against a deep blue, or a pale green against a dark green.

Another physical effect in the eye which differs from that produced by a camera lens is the reduction of contrasts in a wide view seen by the eye as a result of light scattering within it. This scatter is less within a camera, which therefore records colours more brilliantly. That is why the colours of a transparency often seem more saturated than those seen in the actual scene recorded. The brilliance is not necessarily caused by the film itself. To see as the camera sees is easy enough: peer either through a small hole in a piece of cardboard about $\frac{1}{8}$ in. in diameter, or, more effectively, down a tube of cardboard about 3 ins. long and an inch or so in diameter, preferably lined with black velvet. The tube could take a rectangular section, proportional to the rectangle of the frame of the film. Then all the incidental rays will be excluded from the eye, and the brilliance of the actual scene will be greatly increased.

Here are a few working points:

(1) To include as many different and saturated colours as possible in a picture is, generally speaking, about the worst thing you can do. The colours cannot then be composed into a unity; they will argue with each other and the effect, however colourful, will be not only discordant but dull and meaningless. So 'restrict your palette', as the painters say. Make one colour, or a limited range of colours, dominate the whole.

(2) A colour composition should express the subject and

mood of a picture. For example, a restful subject will obviously need calm, cool, harmonious and, possibly, desaturated colours. A more energetic subject can be warmer and more vigorous with strong contrasts in both tones and colours. A gloomy, brooding subject will need debased colours. A horror subject will need violent, possibly discordant, colours.

(3) Everything you see is coloured if you look carefully enough, even in places which, at first sight, seem colourless, and one of the greatest aesthetic virtues of colour photography is its ability to convey subtle colour combinations in subjects which are almost monochromatic. The finest colour photographs can be almost, but not quite, colourless.

(4) The more desaturated colours become, the more easily will they lie together, wherever they fall on the Colour Circle. So also will debased, or greyed, colours. The more saturated colours are, the more carefully they must be combined.

(5) Harmony is assured if you stick to restricted areas of the Colour Circle. A woodland scene when the leaves are turning may be fully harmonious with tawny browns, golds, coppers and yellows; here a touch of a complementary such as blue or blue-grey in the sky may bring greater vitality. Even pure whites or blacks can give enough contrast in such cases, or a brilliant spot of saturated red to contrast with the debased reds and yellows.

(6) Include whites, blacks and greys to serve as vitalizing foils to any colours. Breugel's peasant scenes provide an object lesson in the use of small areas of black and white to enhance the gay colours – perhaps as a white stocking or a black hat.

(7) Much can be learned about pleasing colour combinations by studying natural objects – certain leaves in autumn, lichen on tree bark, wild flowers, insects, rock pools, sea shores, woodlands. But nature is not always an artist. To my eye a

77

pale blue sky above dark grass and foliage is not attractive – at least as revealed on a colour film. (The scattering of light tends to reduce discords when seen by the eye, but the camera will pick them up.)

(8) Use the dominant colour of the composition at the focus, or climax. (If the form of the focus is circular it will have the greatest formal strength, for as red is the most dominant of colours, so a circle is the most dominant of shapes. A red disc is visually the most powerful object in existence.)

(9) Every composition requires contrasts and inner tensions if it is to be alive and interesting, not only in its forms but also in its colours. The aim must be to resolve the tensions and conflicts in the overall coherence. This does not mean that a range of colours which seem at first sight to be almost monochromatic are to be avoided; this would contradict point (3). To maintain the so-called Key of a picture is important; great contrasts are just as possible in a key which is almost colourless and highly desaturated as in one where colours are saturated.

(10) Keep the key consistent; that is to say, keep the degree of saturation or debasement fairly equally balanced throughout the composition. This is particularly important in capturing a lighting mood. Key can be strengthened by an overall cast of colour, such as can be obtained by using a colour filter. This will help to unify a picture, although it will at the same time tend to reduce its colour contrasts.

(11) Aim always to please yourself. Only then will your efforts finally please others. Learn all you can but do not allow rules and self-conscious intellectualization to dominate your deepest intuitions. It has been said well that a knowledge of colour theory does not make an artist, any more than a knowledge of grammar makes a poet.

Part Two

Chapter 5 | *Cameras and Equipment*

How a camera works was described in detail in the Penguin *Photography*. Here, for the beginner's sake, only certain matters of practical importance will be covered, particularly the relationship between lens, diaphragm and shutter, the three main elements of a camera.

The Lens

This may contain as many as nine glass components, although many good lenses have only four. It focuses the image on the film emulsion. A simple, single convex lens would produce a fairly sharp image on the emulsion provided the distance between lens and emulsion was correct, but it would also produce aberrations; for instance, vertical lines would appear curved at the sides of an image, illumination would be uneven, and some colours would be in focus and others would not. So compound lenses are made with some pieces convex and others concave to correct these faults.

The focal length of a lens is important. It is the distance between lens and emulsion at which distant objects appear sharp on the image – that is when the camera is set at Infinity. When we speak of a four-inch lens we mean a lens having a focal length of four inches. Normal lenses have a focal length about as long as the diagonal of the picture they produce. Wide-angle lenses have short focal lengths, and long-focus and telephoto lenses have long ones. Objects close to the camera will not be in focus unless the distance between lens and film

is increased (or unless a supplementary lens, sometimes called a portrait attachment, is used). When that distance is increased distant objects will not then be sharply focused on the emulsion. The larger the lens is and the more light it admits into the camera, the more necessary does accurate adjustment of the distance between film and lens have to be.

A lens of normal focal length is fitted to most cameras, and its angle of view is about 45 degrees, which is wider than the clear vision of the human eye. Wide-angle lenses – that is ones of short focus – take in about 100 degrees, while long-focus lenses may take in only 20 degrees, which is about the same as the eye takes in. Most amateurs are content to use one lens of normal focal length, since this will cover most needs. A wide-angle lens is valuable for photographing buildings, particularly interiors, while a long-focus lens, or a telephoto lens, is useful for picking out details to fill the frame – perhaps a long way off. The long-focus is valuable in colour photography because it serves to bring the subject close.

If a subject is photographed from the same position with lenses of different focal lengths, the lens with the short focus (wide angle) will include in the image everything the long-focus lens includes and much more. So if a picture taken by the short-focus lens is cropped the necessary amount, it will be exactly the same as the picture taken by the long-focus lens, but, of course, it will be much smaller, and, if enlarged, it will be less sharp and may show some grain. Hence the value of lenses of different focal lengths to enable the subject to fill the whole frame.

However, if you take a subject with a long-focus lens and then move closer and take the same subject with a short-focus lens so that in both cases the subject, perhaps a church tower, fills the frame, the two pictures will be quite different, not only in the perspective of the subject itself but in the relationships between it and its background and surroundings. For example

a mountain behind the tower will seem much larger in the distant shot with the long-focus lens than it will in the closer shot with the wide-angle lens. Beginners are often disappointed with their first landscape shots where great mountains appear like distant hillocks. This is partly caused by an illusion of sight. The drama can be retained either by using a long-focus lens or by getting much closer to the mountains.

You can imagine how focal length works merely by looking out of a window. The closer you are to the glass the wider will be the view outside (short focus); the further back from the window you step the more restricted will be the view (long focus).

The Diaphragm

The amount of light passing through a lens is controlled by the diaphragm. This consists of thin metal leaves assembled in such a way that they form a round hole which can be varied in size by a lever or by turning a ring on the lens barrel. It is usually fixed between two of the lens components. When open at its widest it allows the whole lens to be used so that the maximum amount of light can enter the camera when the shutter is opened. When the hole is stopped right down, far less light can, of course, enter the camera, and so a longer exposure by the shutter will be needed than when the diaphragm is wide open.

The smaller the opening, or stop, of the diaphragm is made, the greater will be the depth of focus; that is to say, the more objects both close to the camera and far off will be in sharp focus on the film. The wider the opening, the smaller will be the depth of focus. Depth of focus directly relates to the depth of field, the difference between the two being that the former lies within the camera and the latter in the world outside the camera. The diaphragm thus has two functions: to

83

control the amount of light reaching the film, and to control the depth of focus.

Diaphragm stops are marked with numbers prefixed by the letter *f*, and they indicate a relationship between the diameter of the diaphragm's aperture and the focal length of the lens, the approximate formula being:

$$f\text{-number} = \frac{\text{focal length of the lens}}{\text{diameter of the aperture}}$$

This standard ratio means that cameras can be made so that the same length of exposure can be given at the same *f*-number, whatever the focal length of the lens, provided that the subject photographed, the speed of the film and the lighting conditions are constants.

The smallest *f*-number represents the widest aperture. Each number reduces the amount of light falling on the film by half, the standard *f*-numbers being 1·4, 2, 2·8, 4, 5·6, 8, 11, 16, 22, 32, 45 and 64. Thus an exposure requiring 1/50th second at *f*/8 would need 1/25th at *f*/11 and so on, under the same lighting conditions.

Most cameras of any quality have lenses with widest aperture of at least *f*/4. Lenses with wider apertures are more rare and more costly. At *f*/1·4 and with a fast film, very dark objects can be photographed at a shutter speed of, say, 1/50th second, which means that even interior subjects can be shot with a hand-held camera. Then, of course, focusing would have to be accurate since the depth of field might be only a few inches. The wider the angle of lens, however, the greater will be the depth of field. The very wide stops are found only on lenses of normal focal length; long-focus lenses with wide apertures are not only difficult to make but are almost useless in their restriction of depth of field at the widest stop. A lens with the highest practical speed is made by the Japanese firm, Canon, with the widest aperture of *f*/0·95 for use on a special miniature camera

they produce. Except in unusual circumstances a lens of, say, $f/4\cdot5$ and a shutter working between 1/200th and $\frac{1}{2}$ second will fulfil most needs. (The human eye has aperture ranges between $f/2\cdot3$ and $f/10\cdot4$ – not unlike those of the diaphragm of a good camera lens.)

With diaphragm set at $f/22$, objects only about three feet away from the camera right back to the horizon would normally be in sharp focus; the depth of field would be considerable and in bright sunlight a snapshot could be taken at 1/50th second with the camera in the hand, if a fairly fast film were being used.

The wide-aperture lenses do not necessarily give better definition than those with smaller apertures, even when they are stopped down, and on most modern lenses the best definition is obtained not at the smallest stop but about half-way between the smallest and largest, that is around $f/8$ or $f/11$. (Fast lenses of six or more elements of, say, $f/1\cdot8$ tend to produce a slightly warmer rendering on colour films than the slower four-element lenses.)

What depth of field should one aim at? That depends entirely on the subject and the purpose of the photographer. There is a charm about pictures which have a sharp overall definition, especially when the subject relies on deep perspective for its effect, as in architecture, rather than on a human or documentary story. Often, however, fast exposures are needed so that the widest stop must be used; then part of the subject must be deliberately selected for relegation to out-of-focus fuzziness. Such fuzziness is often an aesthetic advantage anyway, not least in portraiture, where the background may be better if unobtrusively out of focus to some extent. Even an architectural composition may be improved by keeping close objects blurred and distant ones sharp in order to give a sense of depth and increase the brilliance of the distant objects by contrast.

Focusing

Accurate focusing is accomplished by different means according
to the type of camera. In reflex cameras (including the twin-
lens) focusing is easy, for it is achieved merely by looking at
the screen and turning a knob; a magnifier above the screen
focused on a small area of the image will help accuracy, as in
the Rollei. To see exactly how much depth of field you have
at a particular stop the viewing lens of a twin-lens camera
should also have a diaphragm, but this is not often supplied.
However, you can be sure that the screen will reveal the least
depth of field, since it will be at the same aperture as the widest
aperture of the lower, exposure lens. In the single-lens reflex
in which you view through the exposure lens, you can alter the
stop while composing, as you can also on the larger hand-or-
stand cameras where the film or plate-holder can be replaced
temporarily with a ground-glass screen; then the image, which
will be upside down, can be seen in detail through a special
magnifying glass for very accurate focusing.

Some cheap cameras may have no more than a brilliant view-
finder which cannot be used for focusing; then the depth of
field must be worked out on a scale with which cameras are
supplied, and the camera focused by a distance scale marked
in feet. Experience will also help you to judge the depth of field
at various stops. Other cameras, like many non-reflex 35 mm.
types, have rangefinders fitted on them through which the
subject is seen and composed, focusing being achieved by mak-
ing two images coincide by turning the camera's focusing knob;
when the two images join up the camera is in focus. Range-
finders can also be obtained as gadgets on their own to be used
in the hand apart from the camera. Coupled rangefinders are
very accurate, and have helped to make the 35 mm. camera
popular.

The Shutter

While the diaphragm controls the quantity of light entering the camera according to the size of its adjustable diameter, the shutter controls the quantity of light by the length of time during which the light is allowed to enter the camera. Shutters are of two main types: between-lens and focal plane. The between-lens can be divided in turn into several types, which are of two distinct kinds: that which requires a single pressure of a finger to make the exposure and that which must first be tensioned, or pre-set, and then released by a second pressure of the finger. The better between-lens shutters are of the pre-set kind, a well known make being the Compur. They have multi-speeds, a good model giving pre-set exposures from 1/500th up to one second. Long exposures, hours if necessary, can also be made by fixing the shutter blade to stay open; alternatively the shutter can be held open by the finger and then released by removing the finger when exposures of only a few seconds are needed. Such a mechanism is adjusted by the letter B on the shutter ring. (Seconds can be counted out either by adding the word 'thousand' between numbers, or by counting out the number of seconds from zero and then back to zero.)

Almost all shutters these days, even on quite modest cameras, are made for flashlight exposures, so that pressure on the trigger automatically ignites the bulb while opening the shutter. There are two settings for synchronizing flash marked X and M. Most shutters have only the X setting, but some have both. The ignition and burning of the flash bulb takes place within 1/30th to 1/25th second, but a certain amount of time passes until the flash reaches its greatest intensity. So, if the shutter speed is less than 1/30th second, the shutter may be closed before this peak of intensity is reached, and the shot will be under-exposed. For shutter speeds no faster than 1/30th the

87

X setting will suffice. If a rapid shot is required for a fast-moving object with 1/50th second exposure or less, then the M setting must be used, for this involves a pre-ignition of the bulb so that the flash is at its full intensity during the brief exposure. (Further information on flash is given on page 125.)

Another shutter refinement is the delayed action mechanism which is pre-set as usual, and, after a delay of about ten seconds, the shutter automatically opens and closes. By its means the operator can take his place, for example, in a group of people being photographed, or he can act as a figure in an otherwise deserted scene.

The focal-plane shutter, as distinct from the between-lens type, is found on many miniature cameras. This is fixed not between the lens components but close to the focal plane of the camera – that is just in front of the film at the back of the camera. It may be made of fabric or metal in which there is a slit which allows light to pass on to the film as it travels across the film's surface when a spring is released. The exposure time depends on the size of the slit and the speed at which this moves across the surface of the film. An advantage of this type of shutter is that only one shutter is needed, however many different lenses the camera has. It also gives very high and accurate speeds up to 1/2,000th second. On the other hand, it has the disadvantage that, although the actual exposure time on any part of the emulsion will be as set, the time taken for the slit to pass right across the surface will be longer. This will not matter unless the subject is moving, but if it is some distortion of the image may result. A motor car, for instance, may appear foreshortened if the car is moving in the opposite direction to the slit and lengthened if it is moving the same way. Another disadvantage is that it is not effective when using flash bulbs.

Most shutter triggers take the form of small knobs or plunging levers, but these can usually be extended by screwing

on a cable release some six inches long. This may help to produce a steadier exposure, and it can be used to keep the shutter open for long periods if the shutter itself does not contain the mechanism for doing so, but only a B mechanism; then the cable release must be of the sort which has a small metal screw at the end to hold the cable in a fixed position. Very long cable releases up to 34 feet can be obtained for use when the photographer wants to be at some distance from the camera when he exposes, as when recording wild life. If such a release has a bulb at the end for foot operation, it can also be used when the photographer wants to be in the picture himself, and has no delayed action on his shutter.

Camera Types

Almost all amateurs and most professionals now use two sizes of camera, both in the miniature class: the 35 mm. taking frames 1 by $1\frac{1}{2}$ ins. (24 by 35 mm.) on sprocketed film, and the $2\frac{1}{4}$ ins. square (6 mm. square) single lens, or twin-lens, reflex. Both are good sizes for colour photography because both make slides which fit the standard viewers and reflectors, whereas the larger sizes outside the miniature class from $2\frac{1}{4}$ by $3\frac{1}{4}$ ins. frames upwards do not. (The first 35 mm. camera was made by Leica in the 1920s especially to test cinema films, and it opened up a whole new world in photography.)

For some time only colour films to fit the 35 mm. cameras were made, and this is still the most popular size, partly because the cost of each picture is lower than that in the larger sizes. Moreover, the standard lenses of 35 mm. cameras provide a fairly wide angle giving considerable depth of field; it is the best camera for taking moving subjects in poor light.

Probably the most suitable camera of any for amateur colour photography is the 35 mm. single lens reflex. This has a viewfinder which shows the actual scene as the film will record it

right up to the instant of exposure so that composing and focusing are easy, rapid and accurate. The best of such cameras have interchangeable lenses of varying focal lengths. Some non-reflex 35 mm. cameras can now be converted to reflex by a special attachment.

The general advantages of the 35 mm. cameras, whether reflex or rangefinder, are: (1) More kinds of film, both colour and black-and-white, and of varying speeds, are made for this size than any other, including Kodachrome, the most popular of films, (2) The best services exist all over the world for processing the films, (3) They are precision-made, small and tough, (4) They are comparatively inexpensive to run, their films giving either 20 or 36 shots in a single cassette, (5) Many have interchangeable lenses, even from 8 mm. fish-eye to at least 2,000 mm. telephoto, (6) They can be used at eye level, a more natural position which many prefer. The 35 mm. reflex has particular advantages: the image can be seen clearly and exactly as the lens sees it without parallax discrepancies, and with the depth of field clearly visible.

The 2¼ ins. square format camera, using 120 or 620 size roll films, produces larger slides which can be clearly seen without an enlarging viewer and will provide slightly sharper images when projected on to a large screen than those of the 35 mm. format. If the aim is to make colour prints from colour negatives rather than positive transparencies, then the larger size is an advantage. It is also an advantage if photographs are to be reproduced in printed magazines or books. The larger cameras can also be an advantage if they are to be used for black-and-white as well as colour, in that enlargements will show less grain. Moreover, processing of 35 mm. films must be more carefully done, and scratches and dust spots will be more apparent in enlargements.

The 2¼ ins. square camera generally takes the form of the popular twin-lens in which the upper lens serves only to throw

the image on the ground-glass screen at the same size as the recorded image, while the lower lens takes the picture. This makes focusing and composing very clear and easy. Typical and famous models are the Rolleicord, Rolleiflex and Mamyia-flex. Disadvantages of twin-lens cameras are: (1) Lenses cannot be interchanged in most models, the Mamyiaflex being an exception, (2) Film holders cannot be interchanged, (3) When used for close work, the image in the screen does not exactly coincide with that recorded on the film (parallax) unless a special adjusting mechanism is incorporated in the camera, (4) The camera is designed for use at waist or chest level (not always a disadvantage, however).

The single-lens $2\frac{1}{4}$ ins. square reflex type is preferable to the twin-lens if you can afford it, the most famous models being the Swedish Hasselblad and its Japanese equivalent, the Bronica. This type approaches the unattainable ideal for general use, its one lack being a rising front, which is invaluable in architectural work when tall buildings must be included within the frame without sloping the camera upwards. Except for the Nikon, all other miniatures also lack this useful movement, but the problems raised can be partly overcome by using a wide-angle lens. Both Hasselblad and Bronica have both interchangeable lenses and film holders. The latter are an advantage if you want suddenly, for example, to change over from one kind of film to another without using up all one film first – say from black-and-white to colour, or from a slow to a fast film. Some 35 mm. cameras, like the Contaflex, also have interchangeable film holders.

A type of camera half-way between the 35 mm. proper and the $2\frac{1}{4}$ ins. square is one taking frames $1\frac{5}{8}$ ins. square to form so-called Superslides. Such is the Rollei-Magic twin-lens reflex, which normally takes the 120-size roll film but can be set for 16 frames of either $1\frac{5}{8}$ by $2\frac{1}{8}$ ins. or a $1\frac{5}{8}$ ins. square format. Cameras are now being made specially to take $1\frac{5}{8}$ ins. square

transparencies on 120-size roll film at 16 frames a roll; a certain amount of film is then wasted at the edges but these edges can serve for handling. Other cameras using 127-size roll film can produce 8 frames at $1\frac{5}{8}$ by $2\frac{1}{4}$ ins. or 12 frames at $1\frac{5}{8}$ ins. square format. This $1\frac{5}{8}$ ins. square Superslide format is an excellent one in that transparencies can be inserted in projectors designed only for 35 mm. slides and yet be slightly larger than the normal slides in one of the two directions. The normal Rolleiflex, incidentally, has an attachment called the Rolleikin which will take 35 mm. film; then a mask is placed in the viewfinder and the lens acts as one having a long focus. Of course, the full $2\frac{1}{4}$ ins. square transparencies can always be cut down either to normal 35 mm. format or the Superslide format if necessary, but this wastes much film.

Tiny sub-miniature cameras, which can be slipped into a waistcoat pocket, now exist. Although they can produce tolerable results and have their uses, not least to directors of spy films, the format is rather too small for convenience. One model is the GaMi 16 taking 16 mm. movie film which produces frames 12 by 17 mm. on unperforated film and 10 by 17 mm. on perforated. Other makes are the Rollei 16, the Minox, the Minicord, the Stylophot and the Yashica Atoron. A compromise between the full 35 mm. and the 16 mm. is the half-frame camera taking sizes 18 by 24 mm., or 24 mm. square, on standard 35 mm. film.

A few amateurs, and many professionals, use large cameras outside the miniature range, taking either 120-size roll film and producing frames $2\frac{1}{4}$ by $3\frac{1}{4}$ ins., or sheet film in plate holders producing frames 4 by 5 ins. or larger. Even 8 by 10 ins. is common in professional studios. A type of camera, which the enthusiastic amateur may sometimes acquire, but which is generally considered to be a professional one, is the bellows, hand-or-stand camera taking either 120 roll film or cut film. A well-known example is the Linhof Technika. Here are inter-

changeable lenses, film- or plate-holders, most of the movements such as rising front and swing back, and double-extension bellows for macrophotography. These are the most versatile of instruments, particularly in the mono-bar group, though not the kind you use if you want to keep down running cost in films or carry about for comfort on holidays in hot weather.

The trend in miniature cameras is towards automation, and many models now have built-in light meters with cadmium cells which control the diaphragm stop to give correct exposure. Then all you need do is press the button. Manual adjustments between shutter speed and diaphragm stop are not needed, and no knowledge of such matters as the inter-relationship between stop, shutter, and depth of field is required. Once you have fixed a lever according to the speed of the film you are using, the camera does the rest by itself. A red signal in the viewfinder shows you when there is not enough light available to give an adequate exposure. The Kodak Instamatic cameras, taking Kodapak film cartridges, even set the shutter automatically for the film speed when you slip in a cartridge. Nothing could be more simple. Although not foolproof, these cameras are a boon to the casual amateur.

A disadvantage of full automation is that the diaphragm is automatically adjusted to the shutter speed when exposing, the shutter speed being fixed according to the film speed after the film has been inserted in the camera; so, when a fast film is used, the shutter may have to be set at its highest speed, and this means that in poor light the full aperture of the lens may not be available; the full aperture will only become available when using slow films and the whole object of using a fast film will then be lost.

The better automatic cameras show both shutter speed and lens aperture at the edge of the viewfinder, and then by altering shutter speed the aperture is automatically adjusted and vice

93

versa. Any desired combination of stop and shutter speed can thus be selected. This is called a semi-automatic method and has distinct advantages over the fully automatic method. The best arrangement, however, is one where the automation can be disconnected when desired. Automation does restrict personal control a good deal, especially of the depth of field, and the meter reading may not be selective enough in tricky lighting; it will only give you a general reading from the direction in which the camera is pointing, and that may not be enough for shadow areas – for instance in a portrait taken against strong light.

In the new Leicaflex, which incorporates a cadmium light meter, you can pre-select your diaphragm stop and, by turning the shutter-speed knob, you obtain the right speed visually in the finder; alternatively you can pre-select your shutter speed and visually adjust the stop. Both adjustments are made by lining up the meter needle, visible in the finder, either with the shutter speed marker or the diaphragm stop marker.

The latest, most accurate and sensitive way of measuring light is through the lens (TTL) by means of the cadmium sulphide photocell. The new Super BC Contaflex, with semi-automatic exposure control, has such a metering, which gives integrated readings of very wide range at the outer pupil of the viewfinder. Another camera with a TTL exposure meter is the Nikkosmat.

Another fairly recent development is the zoom lens which has been used on film and television cameras for a long time and is now available on some 35 mm. still cameras. Examples are the $f/2.8$ Voigtländer Zoomar for use with the Bessamatic 35 mm. reflex, and the Nikon Zoom. These lenses have varying focal lengths and can be adjusted from, say, a 30 degree angle, long-focus view to a 60 degree wide-angle view; Nikon make three zoom lenses: 43–86, 85–250, and 200–600 mm. The zoom eliminates the need for a number of interchangeable lenses.

This is another useful simplification, but the lenses are unavoidably rather protuberant, heavy and expensive.

Equipment

Apart from the camera itself, other equipment might include camera case, lens-cap, lens hood, tripod, light meter, various colour filters, flash lamp, and one or two flood lamp holders – not including any darkroom equipment for processing and printing, such as an enlarger, which may be wanted.

Only camera case and lens hood may be regarded as starting essentials. The case, almost always supplied with the camera, is a valuable protection against blows and the weather. The best cases are of thick leather and have their fronts hinged so that the camera can be operated in its case.

A cap of plastic to cover the front of the lens when not in use is advisable (or caps for both ends when the lens is removable), because lenses are made of soft glass and are rather vulnerable to scratches and finger grease.

A lens hood is invaluable and should always be fixed to the front of the lens before exposure. Sometimes it is built into the camera or lens. A hood can never do any harm provided its size is right for the lens, and it will often do some good in cutting out incidental, unwanted, scattered light which could cause flare within the camera, perhaps from the sun, a bright sky or a strong reflection from snow or water – light sources which may lie just outside the angle of view of the lens. By using a lens hood crisper results are likely to be obtained. The hood should be as deep as possible, but its edges should, of course, come outside the field of view of the lens. A hood suitable for a lens of normal focal length may be unsuitable for one of short focal length (wide angle) in that it may cut off the corners or edges of the subject. When a rising front is well raised, a hood may cut off the top corners of the image. An added advantage

of a hood is that it will protect the lens against knocks and rain drops.

Tripods may be a nuisance to carry around, but for some shots they are valuable for two main reasons: they ensure a sharp exposure without the slight camera shake which can so often occur when the camera is hand-held at shutter speeds longer than 1/50th second, and the composition can be carefully arranged so that, for instance, in an architectural shot the verticals of the structure will appear quite vertical in the photograph.

A tripod should always be sturdy and extendable to the level of the eye. The little light affairs are not much use for they are unstable and will vibrate in a wind. A good type is made of light metal with extendable legs and a central shaft which can be raised or lowered. A head which can be adjusted two ways, or even three, is a useful attachment. A compromise is to use a monopod in the form of a walking stick; with this and perhaps the side support of a wall or tree quite long exposures can be made successfully. Clamps can also be obtained which can be attached to a table edge, chair back, fence or similar support; also chains whose upper end can be screwed into the tripod bush of the camera and lower end held to the ground by the foot so that by pulling up the chain some extra stability is gained. With cameras held at chest or waist level, steadiness can also be gained by pulling down the neck strap of the camera or its case. (Hold the breath while exposing to help steadiness and do not jab, but gently squeeze, the trigger.)

A light exposure meter, such as the famous Weston, is a luxury which helps to provide that accurate exposure which reversal colour films need. As we have seen, many cameras now have light meters built into them. For more serious work a separate meter is preferable for this can be moved about and pointed in any direction so that a general, mean reading can be

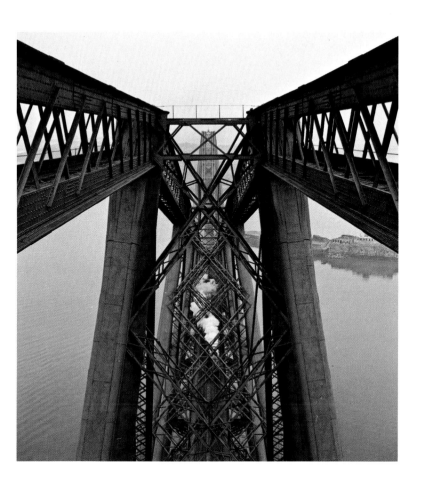

9. Eric de Maré: *Painted Steel*

10. Eric de Maré: *The Forth Railway Bridge*

11. Cornell Capa: *The Huddle*

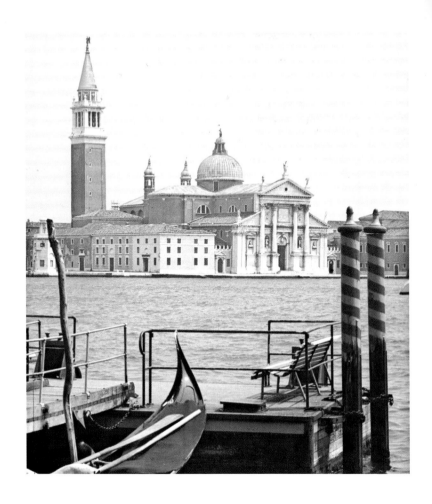

14. Eric de Maré: *Venice*

15. Ernst Haas: *Norwegian Fjord*

16. Geoffrey Ireland: *Portuguese Village*

17. Eric de Maré: *Recording: Ormolu Bust*

18. Eric de Maré: *Recording: Painted Ceiling*

19. Howard Sochurek: *Infra Red: Ships in Harbour*

calculated; this may not always be necessary but where a subject is full of contrast, and the correct exposure may not be according to a reading given by a built-in meter pointing straight ahead, a separate meter is valuable. For example, in a wide landscape taken from a hill and having a great amount of bright sky, the reading of a meter pointing straight ahead might be far too high.

Amateur exposure meters are of the photo-electric type using selenium cells, and they cost around £10 new. The meter is first adjusted to the speed of the film, and, when pointed towards the subject, a needle will indicate a figure; then you can read the required figures for stop and shutter speed. Most good meters can be adjusted to two readings, one for daylight, the other for poor light indoors or in dark shadows. Sometimes, however, the light is so poor that the needle will not budge and no reading is possible. Then you will have to guess the exposure; happily the less the light is the longer the exposure can be without the risk of over-exposure. Alternatively you can use a new type of light meter which uses a cadmium sulphide cell and is highly sensitive. The Gossen Lunasix is of this type; it will give a reading even in moonlight, being over 100 times more sensitive than any conventional photo-electric meter; it will even give a reading for daylight through a hand, and it can be used on the large 4 by 5 ins. cameras to measure the light very precisely on the film plane itself. Although instructions supplied with the meter will help, you must use these sensitive light meters in very poor light with caution because the reading must be adjusted for reciprocity failure. This is an important matter in long exposures and means that the longer an exposure is the less does the light affect the film; so exposure may have to be double or treble what the meter indicates. The longer the exposure the greater will the reciprocity failure be. Unfortunately in a colour film the three layers will be affected in different degrees by reciprocity failure and so distinct colour casts may

be produced unless appropriate colour compensation filters are used. (These are discussed in Chapter 7.)

Note that placing a colour filter over a light meter will not give a correct reading for a shot for which the same filter will be used on the camera.

For normal shots outdoors light meters are not essential. If your camera is not automatic, you only have to follow the instructions on the leaflet which comes with the film. Or you can use an Exposure Table or Calculator costing only a few shillings.

Chapter 6 | *Films*

What type and make of film should you use? That depends on what you want. The first decision must be whether you want positive transparencies, or colour prints, or both. In the first case you will choose a reversal (positive) film, in the second a negative film from which prints can be directly made, and in the third a negative film also from which both transparencies and prints can be made.

Positive or Negative?

One advantage of negative colour film is that you can have as many prints made as you want up to large sizes, whereas the positive transparency is a single object of small, fixed size. Of course, you can have transparencies duplicated or re-photographed in negative form (called an inter-negative), and you can have positive transparencies made from a negative, but this is not particularly cheap and the results may lose quality during the transference. Now also Kodak have produced a paper called Ektachrome, processed by a chemical kit called Ektaprint R (as opposed to Ektaprint C for printing from negatives on Ektacolor paper), from which prints can be directly made from positive transparencies.

Another advantage of the colour print is that you can look at it in the hand without trouble at any time, whereas the transparency to be fully enjoyed must be projected in the dark on a screen during brief, special periods – or at least seen in a respectable viewer. But the main advantage of the negative-

positive process over the reversal film is that far greater control of the final print is possible than with the transparency. Although a little control of any film is possible during processing, such as reducing or increasing contrast, and, in the case of a transparency only, after processing by mounting it with a gelatine filter of pale colour (pale yellow to reduce a blue cast, for example), the main control of a reversal film must come during exposure by the choice of lighting and by colour correction filters. In a studio, of course, great control of colours is possible by using lights covered by coloured gelatine sheets, the colour temperature of which is known. But a very high degree of control is possible when making a colour print from a colour negative, both locally and overall – in degree of contrast, in balancing the ratios of the three colours, in degree of saturation, in the correction of converging verticals by sloping the enlarger base or lens.

Still another advantage of negative films is that, although they do not attain the high speeds of some reversal films, they can be allowed twice the exposure latitude of reversal films. Use of correction filters during exposure need not be so precise, since full corrections can be made during print enlargement in the dark-room. Moreover, you are not restricted to the smaller sizes with negative film as you are with reversal, at least if you want to use a standard projector.

What is more, a black-and-white enlargement can be made directly from a colour negative by using the panchromatic Kodak paper, Panalure, whereas with a transparency a contact black-and-white negative must first be made on panchromatic film, which can then be printed on an ordinary bromide or similar paper.

The ideal situation would be one in which at reasonable cost one could take every shot on negative colour film and receive back from the trade both a good colour print and a positive transparency.

It may seem from the above summary that the negative film scores over the reversal all down the line, but this is not necessarily so. For one thing prints cost more than transparencies, although against that must be balanced the outlay of the viewer or projector which transparencies need if they are to be seen at their best. A really good colour print must be a tailor-made job executed with skilled craftsmanship; the mass-produced enprint made by well-known manufacturers and processors is tolerably good if the original negative is good, but altering colours, composing by cropping and other controls cannot be achieved. When done professionally on tri-pack paper like Ektacolor, enlargements are fairly moderate in price, but to get the most perfect print by dye transfer can be very costly. The dedicated amateur, however, will want to make his own colour prints, however much time and trouble this may take.

A distinct disadvantage of the colour print is that it is seen in reflected light and does not give the same sparkling brilliance of a transparency which is seen in direct light. While the contrasts between darkest shadow and most brilliant highlight in a transparency may be as high as 200 to one, that in a print will be no more than 50 to one at the best, unless it is spot-lit in dark surroundings.

Some negative colour films, notably Kodacolor and the new Agfacolor CN17 Special, contain integral colour masks. Photographic dyes do not fully absorb all the colours they should, and they absorb some they should not. They are not perfect, and to overcome their deficiencies certain negative films have these built-in correcting masks in the form of small additions of compensating dyes in the cyan and magenta layers. These do tend to improve a print and to make its colours slightly more saturated than would be the case without the masking.

Both prints and transparencies will fade if kept in bright light for some time, and dyes are also affected by damp and

heat. These will not normally affect the transparency in a light-tight box, nor to any great degree the print kept in an album, but it will affect the normal type of colour print hanging on the wall in a bright room, possibly after only a few months.

Types of Film

Colour films, both reversal and negative, are generally available in the two main sizes: the standard 35 mm. perforated in cassettes containing 36, 20, or 12 frames, each 1 by $1\frac{1}{2}$ ins. (24 by 35 mm.), and in 120-size roll film, which is the same as the 620 size but on a spool of wider diameter, these taking 12 frames at $2\frac{1}{4}$ ins. square or 8 frames at $2\frac{1}{4}$ by $3\frac{1}{4}$ ins. There is also the 127 size producing 12 frames in the $1\frac{5}{8}$ ins. (40 mm.) square Superslide format or 8 frames at $1\frac{5}{8}$ by $2\frac{1}{4}$ ins.; the Bantam film 828 taking 8 frames $1\frac{1}{8}$ by $1\frac{5}{8}$ ins. (28 by 40 mm.), and the 126 Kodapak cartridge taking 12 or 20 frames $1\frac{1}{8}$ ins. (28 mm.) square.

These Kodapak cartridges are handy for those without any knowledge of photography when used in automatic cameras. They have been designed for use in the Kodak Instamatic range of cameras but a few other makes now take them. The cartridge can be slipped into the camera with ease, and it adjusts the camera automatically to the film's speed. The 126-size cartridges are available in Kodachrome-X, Ektachrome-X, both giving 20 frames, and Kodacolor-X, giving 12 frames. (Verichrome Pan black-and-white film is also available, giving 12 frames.) The cartridges are basically 35 mm. size but have perforations only on one edge.

Two main types of emulsion are available in reversal films, one balanced for daylight (generally called D) and the other balanced for artificial light (generally called A), the latter being subdivided into films for photofloods and those for studio lamps. The F type, balanced for clear flash bulbs, is now obso-

lescent. Daylight films can be used not only in daylight but also with blue flash bulbs and electronic flash, without filters, while artificial light films can generally be used in daylight with an appropriate filter but with little extra exposure. Daylight films can also be used with a blue filter in artificial light, but then the exposure must be increased at least four times.

The speeds with which films react to light vary greatly and this must be taken into account when exposing. For instance Ektachrome-X needs two-and-a-half times the exposure of High Speed Ektachrome. The first advantage of high speed in films is obvious: shorter exposure in poor light with the possibility of greater depth of field. Fast films tend to give less contrast than slow, and so they have more latitude; shadow colours show more gradation and more detail. But this is not always so; Kodachrome-X, for example, has more contrast than the slower Kodachrome II. Fast colour films are by no means merely for emergency use, and they may well be a photographer's exclusive choice. In black-and-white, the faster the film the more the grain will show, but this does not apply to colour films to the same extent because during processing a smearing of the silver halide grain clusters occurs. Fast colour films, however, do tend to show slightly more grain than slow, together with a little loss of sharpness. This only becomes a nuisance in macrophotography or photomicrography where very sharp resolution is wanted. In the larger sizes of frames the grain will not be troublesome.

Films and their Speeds

Several ways of denoting film speeds have been used in the past – Hurter and Driffield, Scheiner, General Electric, Weston, Kodak, DIN, ASA, and BSI. That has been confusing, but now only three systems are in general use: DIN (Deutsche Industrie Normen), ASA (American Standards Association),

103

and BSI (British Standards Institution). Of the three, ASA is now most commonly used. The three are similar, but DIN and BSI are logarithmical whereas ASA is arithmetical. They are compared in the columns below. Each column gives a figure needing half the exposure of the one before it, reading from left to right, which means that either the shutter speed must be halved for each step, or the next diaphragm stop must be used, or a mean between the two. Note that DIN and BSI go up three digits at a time, while ASA is doubled each time.

DIN/10 degrees	12	15	18	21	24	27	30
BSI in degrees	22	25	28	31	34	37	40
ASA	12	25	50	100	200	400	800

Here is a list of some well-known colour films available in 1973 in the United Kingdom with their sizes, types, speeds, and processing requirements. Many of the films can be processed by the amateur with proprietary kits, but Kodachrome must be processed by the manufacturer. Negative films are balanced for daylight or blue flash bulbs, but can be used in any light if adjustments are made during printing; it is better, however, to use conversion filters when exposing than when printing.

Reversal (positive) Films

		Types and Speeds		
Name	Sizes	Daylight	Tungsten	Processing
Agfacolor CT 18, CK 20	35 mm., 120/620	Type T ASA 50	Type K ASA 80 3,200° K	Trade and professional (CK 20 amateur)
Anscochrome 64 (GAF)	35 mm. (20 or 36 frames), 127, 120	ASA 64		Trade and professional

Name	Sizes	Daylight	Tungsten	Processing
Anscochrome 200 (GAF)	35 mm. only (12 or 20 frames)	ASA 200		Trade and professional
Anscochrome 500 (GAF)	35 mm. only (20 frames)	ASA 500		Trade and professional
Anscochrome T100 (GAF)	35 mm. only (12 frames)		ASA 100 3,200° K	Trade and professional
Ektachrome-X	35 mm., 828, 126, 127, 120/620	ASA 64		Trade and professional
Ektachrome High Speed	35 mm., 120/620	ASA 160	Type B ASA 125 3,200° K	Trade and professional
Ferraniacolor CR50	35 mm., 120/620	ASA 50		Trade and amateur
Fujichrome	35 mm. only	ASA 100		Trade and professional
Kodachrome II	35 mm., 828 in daylight film only	ASA 25	Type A ASA 40 3,400° K	Manufacturer only
Kodachrome-X	35 mm., 126 and cartridge	ASA 64		Manufacturer only
Perutz C18	35 mm., 127, 120	ASA 50		Trade

Negative Films
(all balanced for daylight)

Name	Sizes	Daylight	Tungsten	Processing
Agfacolor CNS	35 mm., roll film and 126 cartridge	ASA 80		Trade and amateur
Ektacolor S	35 mm. and roll film	ASA 100		Trade and amateur
Fujicolor N 100	35 mm. and roll film	ASA 100		Trade and professional
Kodacolor-X	35 mm., 126, 127, 828, 120/620	ASA 80		Trade and amateur

Colour Photography

A point to note is that given speeds of films adjusted for artificial light, like High Speed Ektachrome Type B, are adjusted for taking a direct reading from a light meter in the artificial light; no lengthening of exposure is required.

A number of films are also made specially for duplicating both negatives and positive transparencies, or for making negatives from positive transparencies and positive transparencies from negatives, but these are used more by professionals and the trade than by amateurs.

Films vary in their characteristics and colour renderings. All are reliable so that you must use the make which best suits your needs and tastes. Kodachrome (both II and X), for instance, and also Ektachrome-X, produce brilliant, saturated colours while Agfa, Anscochrome, Ilford and High Speed Ektachrome are softer. Kodachrome is outstanding for its resolving power, that is its ability to record details sharply, and it is also constant and reliable. It is an admirable 35 mm. film if you like brilliant colours and the faithful recording of greys over a long tonal range, unlike some films which on a dull day tend to show large shadow areas, such as road surfaces, as indigo. But its reciprocity failure is rapid (see later). Blue skies seem to come out well in Agfacolor, for it is slightly warmer than either Kodachrome or Ektachrome. Anscochrome is well balanced and avoids lurid greens. The fast 200 Anscochrome seems to maintain its brilliance and shows shadows with a rich luminosity. So also does High Speed Ektachrome. Anscochrome is particularly resistant to reciprocity failure. Ferrania is one of the easiest films to process at home; it is slightly on the blue side.

Conditions, needs and preferences are so varied that one cannot state firmly that one film is better than another. My own preference is for the softer films, and therefore the faster ones, but even there I would not dogmatize too firmly since some subjects demand full saturation and others do not. Moreover, a slow film may be needed in bright light when you want to

106

use a wide stop to obtain differential focusing, perhaps with a sharp foreground feature and a blurred background; then even your shorter shutter speed may not allow you to use a stop wider than say, *f*/8, which would probably not give you the focusing effect you want.

Reciprocity Failure

Films vary a good deal in their resistance to the failure of the Law of Reciprocity. This law states that equal exposure should produce equal photochemical effects, no matter what the intensity of the light or the length of the exposure. The law holds good for practical purposes for all films at least between 1/25th and 1/200th second, but some films are far more tolerant than others. The law fails at very short and very long exposures because the speed of emulsions is then reduced, and the failure increases as the exposure grows shorter or longer. In a graph the curve would bend at a rapidly increasing angle as the exposure was increased or decreased. This means that exposures of 10 and 30 minutes might not produce very different negatives, whereas at 1/10th second and 1/30th second, the first might be correctly exposed and the second under-exposed.

Reciprocity failure (see page 116) matters less with black-and-white than with colour films, for black-and-white have considerable latitude. In colour films, however, the failure may affect not only the general exposure but it may affect the three layers differently so that the colour values become distorted; the result may show a strong cast of one colour such as blue. This is of less concern in very short exposures than in long ones, but the failure may have its effect when a brief, bright electronic flash of less than 1/1,000th second is used. In long exposures quite strong colour shifts may result from exposures of less than one second, unless a correction filter is used. Most films develop a blue cast, Kodachrome shows green

very quickly while Agfacolor goes brown. The film most resistant to reciprocity failure appears to be Anscochrome which tolerates exposures of 30 seconds or more without showing colour distortion.

Film Treatment

Heat is bad for colour films, so do not leave them too long in hot sunshine, even if they are in the camera or film-holder, nor within a closed car left in the sun. The cooler films are kept the better, and if they have been carefully stored even those which are older than their marked expiry date may still be viable. In hot climates films can be kept in a refrigerator, but when taking them out for use, they should be allowed to grow acclimatized for four hours – that is until they have reached the surrounding temperature; otherwise condensation may form on the emulsion surface and ruin the exposures. All colour films should be processed as soon as possible after exposure.

Chapter 7 | *Filters*

As we have seen, all colour films are made to give 'correct' colours at certain colour temperatures – correct results being in effect where whites appear white and greys appear grey. Daylight films, for example, are balanced for about 5,800° K, while artificial light films are balanced for photofloods at about 3,400, or studio lamps (Photopearl etc.) at 3,200. So if you want to obtain correct colours in lighting which does not correspond to the colour temperature of the film you are using, you must use coloured filters in front of the lens. These can be of gelatine or glass. Gelatine filters are inexpensive, and, supplied in square sizes of 2 and 3 inches, can be cut and fitted into standard rims to screw on to a thread on the front of the lens barrel. Filters are also supplied as coloured gelatine cemented between clear glasses.

Colour filters are used not only to control the colour temperature of the light reaching the film, but also to adjust the effects of reciprocity failure; and they can be applied by the adventurous to produce colour effects which are deliberately distorted. Obviously you cannot obtain correct colours if you mix your light sources – some daylight with some tungsten, for example – although you can sometimes obtain weird and interesting results that way.

Filters can provide moods in a picture by giving a colour shift to the whole subject. A pale amber filter, for instance, will add a glow on a grey day and will counteract the cold blueness of the light. A light orange filter, sometimes called a shade filter, will counteract the blueness in shadows when the sky is

blue. A pale green filter can be used for sunsets where the reds and oranges are likely to appear more lurid on the film than they seem to the eye. Such use of filters is very much a matter of personal choice.

Except with a polarizing filter (see page 117), the effects of a filter on a film are not those you would see if you placed the same filter over the viewer. The filter would not modify the highlights on the film but would only begin to show results, and with increasing strength, as the tones darken. In a snow scene photographed with a pale yellow filter, for example, the highlights of the snow would remain white on the film, but the middle tones might look slightly yellow. A filter always has more effect, therefore, on an under-exposed shot than on a correctly exposed or over-exposed shot.

Most filters require some addition to the exposure and the increase is called the Filter Factor. Thus a pale yellow filter might need 50 per cent extra exposure, or half a diaphragm stop, in which case the Filter Factor would be $1\frac{1}{2}$.

Types of Filters

There are five main categories of filters:

(1) Ultra-violet absorbing.

(2) Conversion.

(3) Light-balancing.

(4) Compensating.

(5) Eccentric.

Ultra-violet Filters cut out the unwanted U.V. rays which may be strong on a sunny day by the sea or in the mountains; they are invisible to the eye but will be recorded by the colour film. Since the U.V. filters are colourless they need no extra exposure and so, if in doubt about the presence of U.V. rays,

always use the filter in case they are there. A pale yellow filter will cut out U.V. rays anyway, so when using one the U.V. filter can be discarded. Another filter which cuts out U.V. rays is the Haze, or Skylight, filter, which has a pink tinge (such as Kodak's Wratten 1A). This needs no extra exposure and is generally better than a colourless U.V. filter, especially in landscapes because it counteracts greens and blues in, for instance, distant haze or in shadow areas under blue sky. Many people always use a haze filter with daylight film for it reduces blue in shadows, neutralizes excessive greens in foliage, and warms the whole subject very slightly, so pulling the colours together.

When the haze filter is not strong enough to counter excessive blue, as it might not be on a dull day, then a pale amber filter having a factor of $1\frac{1}{2}$ might be suitable. An alternative to the haze filter would be the very pale yellow Wratten 2B which needs no extra exposure.

Conversion Filters convert one type of film into another type – daylight to artificial, for example, or conversely. A film designed for artificial light, such as Kodachrome Type A, if used in daylight without a filter will give very blue results, but an amber filter (Wratten No. 85 or an Ilford No. 161) will correct the colours with a filter factor of $1\frac{1}{2}$. Some people, indeed, like to use a Type A film with an amber filter in daylight because the result is rather warmer than the daylight film would give without a filter.

A blue filter such as Wratten 80B will convert a daylight film for use with photoflood lighting, and the factor may then be $4\frac{1}{2}$. This should only be used in emergency or when a make of film you want to use is not available for artificial lights.

In general it is best to use the filters recommended by the film's manufacturers, the Wratten series, for instance, for Kodak films, but this is not essential. Here only the Kodak

111

Wratten series will be described. A few of their conversions are:

No. 80A (blue) converts daylight films to studio lamps, with a filter factor of 4, or two extra stops. It also converts Koda-colour-X (negative) to studio lamps with a factor of 4.

No. 80B (blue) converts daylight films to photoflood lamps, with a factor of 3 or one and a half extra stops. It also converts Kodacolor-X to photofloods with a factor of $3\frac{1}{2}$.

No. 80C (blue) converts daylight films for use with clear, aluminium-filled flash bulbs (such as PF 24, 38, 45, 60, 100), with a factor of 2, or one extra stop.

No. 80D (blue) converts daylight films for use with clear, zirconium-filled flash bulbs (such as PF1 and 5, and AG1), with a factor of $1\frac{1}{3}$.

No. 85 (amber) converts photoflood films, such as Koda-chrome Type A, for use in daylight with a factor of $1\frac{1}{2}$.

No. 81A (amber) converts studio lamp films, such as High Speed Ektachrome Type B, for use with photofloods, with a factor of $1\frac{1}{3}$.

No. 81C (amber) converts photoflood films, such as Koda-chrome Type A, for use with clear flashbulbs, with a factor of $1\frac{1}{2}$.

No. 81D (amber) converts films for use with studio lamps, such as Ektachrome Type B, to clear flash bulbs, with a factor of 2.

No. 82A (blue) converts photoflood films, such as Kodachrome Type A, for use with studio lamps, with a factor of $1\frac{1}{3}$.

The table opposite for Wratten filters may also be helpful.

Light-balancing Filters are the milder filters for slightly adjusting the colour temperature of the light for an artificial light film, but the principle is the same as that for conversion filters; indeed, the two kinds overlap. The Wratten light-balancing series are all either 81 or 82 with degrees of density

112

Light Source	Colour Temperature °K	Reversal Colour Films		
		Daylight	3,400° K Type A	3,200° K Type B
Sun with clear sky	6,000	None	85	85 + 81A
Cloudy sky	7,000	1A	85	85 + 81A
Electronic flash	7,000	81A	85	85 + 81A
Blue flash bulb	5,500	None	Not recomnd	Not recomnd
Clear flash bulbs	3,800	Not recomnd	81C	81D
Photofloods	3,400	80B	None	81A
Studio lamps	3,200	80B + 82A	82A	None

If you want to work in Mireds instead of degrees Kelvin (see page 33), the following table may be useful:

Amber series		Blue series	
Filter	Mireds	Filter	Mireds
85B	+127	78A	−111
86A	+111	80B	−110
85	+110	82C + 82C	−89
81EF	+52	82C + 82B	−77
81C	+35	82C + 82A	−65
86C	+24	82C + 82	−55
81A	+18	82C	−45
81	+9	82B	−32
		78C	−24
		82A	−21
		82	−10

given in letters A, B, C and D, the 81s being amber and the 82s being blue. They are best listed under their colour temperature changes as in the following table. (Note that Kodachrome Type A film is balanced for a colour temperature of 3,400 to

113

suit photoflood lamps, while Ektachrome Type B is for a colour temperature of 3,200 to suit the slightly redder studio lamps. Manufacturers will always tell you for what colour temperatures their films are balanced.)

Filter Nos.	Filter Factor	Colour Temperature of Film in °K	
		3,400° K: Type A	3,200° K: Type B
82C + 82C	2⅓	2,610	2,490
82C + 82B	2⅓	2,700	2,570
82C + 82A	2	2,780	2,650
82C + 82	2	2,870	2,720
82C	1⅔	2,950	2,800
82B	1⅔	3,060	2,900
82A	1½	3,180	3,000
82	1½	3,290	3,100
81	1½	3,510	3,300
81A	1⅓	3,630	3,400
81B	1⅓	3,740	3,500
81C	1⅓	3,850	3,600
81D	1½		3,800

These amber and blue light-balancing filters are also useful in daylight, amber for reducing blueness in shadows or in dull weather, blue for reducing reds and oranges in early morning or at sunset. Mostly only the paler ones are needed. Nos. 81 and 81A are good when a haze filter may not be strong enough, while at sunset a No. 82 or 82A may serve their purpose. In general amber filters are more often needed than blue ones, since blue is the colour one is mostly trying to neutralize. A warm picture tends to be more acceptable than a cold one, in any case, although sometimes for the sake of expression you may, of course, want to stress blueness.

Filters of any sort are more necessary with reversal films than negative films because control is not possible when processing

the former, but it is possible when making a colour print from a negative by using the appropriate filter packs. However, the more correct you can make a negative from the start, the less adjustments will be needed when printing, and if you have a negative printed by the trade the operator may not know what lighting you used and what filters he should apply for adjustments. It is best to use a filter when exposing negative film to bring the colour temperature back to daylight. Exactly the same filters serve both reversal and negative films.

Compensating Filters, or colour compensation filters as they are sometimes called, are available in the Kodak Wratten series in six colours, each having six densities. The colours are yellow, magenta, cyan, red, green and blue. They are designated by CC for Colour Compensation followed by a density number from 05 to 50, followed by the first letter of one of the six colours. Thus CC20R would represent a colour compensation red filter of medium density.

As a reminder: Yellow suppresses blue

Magenta	„	green
Cyan	„	red
Red	„	blue and green
Green	„	blue and red
Blue	„	green and red

The uses of compensation filters are several. The main one is to enable films to be used with eccentric lighting which is deficient in one or more colours which are outside the colour conversion or light-balancing ranges. For example, a daylight film can be used with a 'daylight' fluorescent lamp by using a CC20B colour compensation filter. Another use of these filters is to restore the colour balance of a film which has passed its retiring age, but this use is only worth bothering about if you have a large stock of obsolete films of the same age and can waste one or two in experiments to discover what

115

filter compensation all the other films will need. They can also be used where you want deliberately and fully to distort normal colours.

The greatest value of compensation filters, however, is to overcome the effects of reciprocity failure. Different makes of films vary greatly in this, but manufacturers will supply information for their own films on how to overcome the problem. Kodachrome fails rather quickly; even after 1/15th second a greenish tinge will be produced and red filters are needed to restore the balance. Filters of increasing density should be used as the length of exposure is increased. But to simplify matters, if you stick to an exposure of one second and vary the diaphragm stop to suit the light available, all will go well with Kodachrome by using a CC10R filter with a factor of $1\frac{2}{3}$, or just over half a stop wider than the light-meter reading will show. With longer exposures you can stick to ten seconds, varying the stop as needed, with a CC20R filter, allowing a factor of $2\frac{1}{3}$ (one-and-a-third stops wider). Note that Ektachrome Type B film is designed to take shots at one second exposure without any reciprocity failure with studio lamps.

Opposite are some recommendations for using compensation filters against reciprocity failure published by the Kodak company. No filters are needed for times even as fast as 1/1000th second. Filter needs begin at 1/10th second for long exposures. The filter factors in the table are given beneath the filter numbers.

To counter reciprocity failure you may sometimes need no filter if exposure is very long. On one occasion when recording a great painted hammer-beam roof, through force of circumstances I had to use inadequate photoflood lighting with daylight film. The exposure was several minutes and on three shots of varying lengths I used a blue 80B conversion filter, and on two of them I also used amber filters of different depths; finally I took a shot without any filters at all and that was the most

116

Film	Exposure Time in Seconds and Filter Factors			
	1/10	1	10	100
Kodachrome	CC05R	CC10R	CC20R	CC25R
Daylight	none	$1\frac{2}{3}$	$2\frac{1}{3}$	$4\frac{1}{3}$
Ektachrome-X	None	CC05Y	CC20Y	CC40Y
Daylight	none	$1\frac{2}{3}$	$2\frac{1}{3}$	$4\frac{2}{3}$
High Speed	CC10B	CC10B	CC0FG	CC05M
Ektachrome	$1\frac{1}{3}$	2	$2\frac{2}{3}$	$4\frac{2}{3}$
Daylight				
Kodachrome Type	CC05R	CC10R	CC20R	CC25R
A Photofloods	$1\frac{1}{3}$	$1\frac{2}{3}$	$2\frac{1}{3}$	4
Ektachrome Type B	None	None	None	None
Studio lamps	none	none	$1\frac{1}{3}$	2
High Speed	None	CC05G	CC10G	CC05Y
Ektachrome Type B	none	$1\frac{2}{3}$	$2\frac{1}{3}$	4
Studio lamps				
Kodacolor-X	None	None	None	None
Negative	none	none	2	4

accurate in its colour values. Reciprocity failure and the imbalance of the film had cancelled each other out.

Eccentric Filters include the polarizing filter and neutral-density filters. The former is used mainly to subdue glaring reflections as from glass, water or a polished surface, but it can also be used to darken blue sky, especially near the horizon and at 90 degrees from the sun; the other colours are unaffected by it. In that way a light-coloured building or white clouds will stand out dramatically against the dark blue. This filter will also reduce the blue cast from ultra-violet radiation and from haze. The filter factor will be 3 or 4. Unlike coloured filters, a polarizing filter will give a similar effect to that produced on a colour film when held in front of the eye, so that by turning

the filter you can tell how reflections will be reduced or blue sky darkened.

Neutral-density filters, also called diffuser or fog filters, are merely grey ones used to reduce light intensity by a known amount without changing the colour balance – perhaps with a fast film in a light too bright or when a wide stop is wanted in a very bright light to reduce depth of field. The Wratten series is distinguished by the prefix ND with eight densities ranging from 0·1 to 2·0. Deeper densities can be built up by combining two or more of the filters. The factors range from 1¼ for ND 0·1 to 10 for ND 1, and 100 for ND 2·0.

Chapter 8 | *Using the Camera*

Unless you are using an automatic camera, the first need when taking a photograph is to assess the light conditions of your subject by using a light meter, an exposure calculator or a table. Relate the reading to the speed of your film and then adjust the relationship between stop and shutter speed to accord with the reading and the film speed – a fast shutter speed and wide stop to capture movement with a limited depth of field, or in poor light – a slow shutter speed and small stop when the subject is still and you want great depth of field – or else a mean according to circumstances. If you are using a filter, its factor must also be taken into account and either the diaphragm opened slightly or the shutter speed made slower.

Exposure

Many new cameras now have shutters which can be set for Exposure Values instead of for *f*-numbers and shutter speeds. This seems to me an unnecessary and confusing complication, but the system, which is based on international agreement applicable to all cameras, has the advantage of reducing the stop-shutter relationship to a single number. The values vary according to the intensity of the light and the speed of the film. Thus a Kodachrome film having a speed of 25 ASA would have an EV of 13 in bright sunshine, but 10 in dull weather, while the faster Kodachrome-X would have respective values of 14 and 11. Each exposure value represents a series of combinations of *f*-number (stop) and shutter speed, so that if you set your shutter to an EV number it will automatically adjust the *f*-number. Below is a table giving the relationships between EV

settings, diaphragm stops and shutter speeds. Note that all the numbers not marked *s* or *m* are parts of a second. The *s* stands for full seconds and *m* for full minutes. Anything over one second will require the B stop.

EV	Shutter Speeds with *f*-numbers									
	1·4	2	2·8	4	5·6	8	11	16	22	32
1	1s	2s	4s	8s	15s	30s	1m	2m	4m	8m
2	1/2	1s	2s	4s	8s	15s	30s	1m	2m	8m
3	1/4	1/2	1s	2s	4s	8s	15s	30s	1m	2m
4	1/8	1/4	1/2	1s	2s	4s	8s	15s	30s	1m
5	1/15	1/8	1/4	1/2	1s	2s	4s	8s	15s	30s
6	1/30	1/15	1/8	1/4	1/2	1s	2s	4s	8s	15s
7	1/60	1/30	1/15	1/8	1/4	1/2	1s	2s	4s	8s
8	1/125	1/60	1/30	1/15	1/8	1/4	1/2	1s	2s	4s
9	1/250	1/125	1/60	1/30	1/15	1/8	1/4	1/2	1s	2s
10	1/500	1/250	1/125	1/60	1/30	1/15	1/8	1/4	1/2	1s
11	—	1/500	1/250	1/125	1/60	1/30	1/15	1/8	1/4	1/2
12	—	—	1/500	1/250	1/125	1/60	1/30	1/15	1/8	1/4
13	—	—	—	1/500	1/250	1/125	1/60	1/30	1/15	1/8
14	—	—	—	—	1/500	1/250	1/125	1/60	1/30	1/15
15	—	—	—	—	—	1/500	1/250	1/125	1/60	1/30
16	—	—	—	—	—	—	1/500	1/250	1/125	1/60
17	—	—	—	—	—	—	—	1/500	1/250	1/125
18	—	—	—	—	—	—	—	—	1/500	1/250

Here are some basic exposures in parts of seconds for films of various speeds in bright sunlight with sun more or less behind you between 10 a.m. and 4 p.m. and between April and September inclusive, or about two hours after sunrise and two hours before sunset:

ASA	Shutter	Stop	ASA	Shutter	Stop
10	50/60	*f*/5·6	50	100/125	*f*/8–11
12	50/60	*f*/5·6–8	64	100/125	*f*/11
16	50/60	*f*/8	80	100/125	*f*/11
20	50/60	*f*/8–11	100	100/125	*f*/11–16
25	100/125	*f*/5·6–8	125	100/125	*f*/16
32	100/125	*f*/8	160	100/125	*f*/16
40	100/125	*f*/8–11	200	100/125	*f*/16–22

For winter months between 10 a.m. and 3 p.m. (GMT) add one stop.

For dark subjects add half to one stop.

For light subjects subtract half to one stop.

For normal subjects against the light add one stop.

For normal subjects with light at side add half a stop.

For hazy sun add half to one stop.

For cloudy-bright light add one-and-a-half to two stops.

For cloudy-dull light add three stops.

For subjects in light shade on a sunny day add three stops.

For subjects in heavy shade on a sunny day add four stops.

In a bright interior multiply outdoor figure by sixty.

For slow-moving figures in the middle distance, a maximum of 1/100th second is advisable and for fast-moving figures 1/250th, but the nearer the figures are the faster the shutter speed should be. Figures moving towards or away from the camera will need only about half the speed compared with those moving across the camera's field of view. A racing car might need 1/500th second or less, unless panning is used (moving the camera at the same relative speed as the car, as you expose).

Exposures on reversal film must be more exact than on either negative colour film or black-and-white. This does not mean, as is often believed, that reversal films necessarily have less latitude than negative or black-and-white, but that any slight degree of either under- or over-exposure will be obvious in a transparency and it cannot, as a negative can, be adjusted during printing. In making a black-and-white enlargement, for instance, control is possible in both varying exposure in the enlarger and the strength of the developer, as well as in choice of grade in bromide printing paper, whether normal, soft or hard (having strong contrasts). An over-exposed positive transparency will be thin with de-saturated colours, while an under-exposed one will be dense in the shadows and have very

saturated colours in the lighter parts. In very bright light, a film like Kodachrome II can be allowed a speed of 32 ASA instead of its normal 25 ASA, if rich colours are wanted.

If you are in doubt about correct exposure time, it is advisable to waste two frames by taking three shots, one at the supposedly correct stop (or shutter speed), one at half a stop less, the third at half a stop more. With five shots, the two additional ones being at full stops, you will almost certainly obtain one perfect result. This is called bracketing.

An important point to bear in mind is that the *f* ratings of lenses and therefore all exposure calculations hold good only when the lens is set at the focal length of the film – that is when set at Infinity. This is not a critical matter until you take very close shots, say at 3 feet or less, that is within ten times the focal length of the lens. Then to achieve sharp focus the distance between lens and film will have to be greatly extended and the length of exposure with it. The formula for calculating the required increase in exposure for normal types of lenses is:

$$\text{Effective aperture} = \frac{\text{nominal aperture} \times \text{extension}}{\text{focal length of lens}}$$

Example: if the meter reading gives 1/10th second at *f*/8, the extension of bellows is double that at Infinity, and the focal length of the lens is 100 mm., then

$$\text{EA} = \frac{8 \times 200}{100} = \frac{16}{1} = f/16$$

So the exposure must in this case be quadrupled: $\frac{1}{2}$ at *f*/8 or 2 seconds at *f*/16.

As we have seen, the colour temperature of daylight varies according to the time of day and the quality of the light. On the whole, midday is not the best time for photography because the sun is then high and shadows are short. Portraits at midday are particularly prone to give unflattering shadows in the hollows of the face, but reflectors in the form of white sheets of

122

paper will reduce the contrasts (a newspaper will help at a pinch). Most portraits are better in soft light. If you do not mind going to some trouble with outdoor portraits, a large white translucent sheet stretched between poles and held above the subject outside the view of the lens will produce a soft and charming light.

In a brightly lit subject the intensity of light between highlights and shadows may be as high as 1,000 to 1. Normally it is nearer 200, or 300, to 1, and only rarely can a transparency achieve even this limited range. A colour print can do so only when spot-lit in a dark room. So the photographer, like the painter, must squeeze the light intensities of his subject into the limited intensities his medium allows. This means that you may have to decide whether to expose for the shadows or for the highlights in a subject having strong contrasts. Then bracketing can be particularly useful. Note that the sharper a picture is overall the greater will its contrasts seem; a picture with a good deal of its background in an out-of-focus fuzz, that is when depth of field is limited, will seem to have less contrast than the same picture would if all the background details were sharply in focus, even though both shots have had the same exposure.

Except possibly for architectural subjects, brilliant sunshine is not generally so good for colour photography outdoors as diffused sunlight which reduces the contrasts. Unlike black-and-white photography, which requires greater contrasts and is on the whole most effective in bright sunlight, whatever its subject may be (excluding portraiture), colour photography can be at its most effective in dull weather – even when rain is falling. That is because it depends more on coloured areas than on the strong three-dimensional forms and textures as black-and-white does. Moreover, it can then capture atmospheric mood. When photographing in dull weather, use a weak yellow filter (Wratten No. 81A or 81B) increasing the exposure above

123

the meter reading by half a stop, for this will increase the general luminosity of the photograph above that of the subject itself.

Tungsten Lighting

This includes: (1) The ordinary domestic lamps lasting about 1,000 hours and having a colour temperature of between 2,600° K in low-wattage lamps, and 2,900 in high-wattage ones. A blue filter will make this light acceptable to artificial-light films, but, although they can be used in an emergency, they are not really bright enough or blue enough for colour photography.

(2) Studio lamps, having different proprietary names such as Photopearl, Argophot, Nitrophot, last about 100 hours. The smaller ones have a wattage of 500, their colour temperature being 3,200. These are excellent for indoor work, especially portraits, and a number of films are made to balance their precise colour temperature so that no filters are needed with them. The lamps need special holders for they are made only with screw caps; alternatively they can be fitted with an adapter having a bayonet cap at one end. They are generally used on adjustable stands with reflectors. A glass-wool diffuser can be fitted in front of the reflector to soften the light, and so can colour filters of glass or gelatine. High wattages are obtainable above 500 for professional studios.

(3) Photoflood lamps for Type A films emit a slightly more brilliant and bluer light than studio lamps. They are over-run and last from 3 to 6 hours of burning, the colour temperature being 3,400. Two sizes are available: No. 1 at 275 watts and No. 2 at 500 watts. Both are available with either screw or bayonet caps, and with either pearl glass or a silvered reflector back. These also are best used on special adjustable holders with reflectors. They tend to burn slightly too blue during their

124

first ten minutes, and become slightly too red after two thirds of their lives have passed.

For the use of those without a light meter, here is a working exposure guide for one No. 2 photoflood with reflector, or two No. 1 lamps with reflectors:

Film Speed ASA (including allowance for tungsten)	Shutter Speed in Seconds	Lamp to Subject Distance in Feet				
		3	4½	6	9	12
16	1/8	f/8	f/5·6	f/4	f/2·8	f/2
40	1/15	f/9	f/6·3	f/4·5	f/3·2	f/2·3
100	1/60	f/11	f/8	f/5·6	f/4	f/2·8

With Type A film in photoflood lighting, no filter is needed. With Type B (films for studio lamps), Wratten No. 81A with ⅓ stop extra will be needed.

The great advantage of tungsten lighting over flash bulbs is that (1) the lamps can be adjusted before exposure to give just the effect you want and can see, (2) the lighting can be softened if needed, either with screens such as glass wool or by reflecting fully or at a half-angle on to a white surface such as wall, ceiling, white paper, or cloth, and (3) the light can be measured exactly with a light meter (adding 50 to 100 per cent extra exposure, or half to one stop, to the reading).

Flashgun Lighting

This is of two kinds, either expendable flash bulbs or electronic flash apparatus. Both have the advantage that their colour temperatures and intensities are consistent.

Flash bulbs are filled with a combustible substance, either zirconium or aluminium alloy lying in oxygen, which is

125

exploded by means of a small electric battery, either by making contact by finger pressure independently or, when attached by wire to a bush on the camera, by pressing the camera's shutter trigger so that the explosion takes place automatically when the shutter is released. Even cheap cameras now have such synchronized shutters. Flash bulbs are made either of clear glass or blue-coated glass, and the blue are tending to oust the clear as the films adjusted for clear flash bulbs are disappearing from the market. Clear flash bulbs are, however, still useful when using negative colour films and they can be used with films like Kodachrome A (3,400° K) with a No. 81C filter, or with films like Ektachrome B (3,200) with a No. 81D filter, their colour temperature being 3,800. The blue flash bulbs have a colour temperature of about 5,500 which is similar to daylight.

The normal flash bulb as used by most amateurs, such as PF1 which is clear and PF1B which is blue (both with the same light power), gives a flash duration of 1/50th second for the smaller M (for Medium) type and 1/30th for the larger S (for Slow) type. With these the common X setting of the camera shutter is used at a speed of not less than 1/30th or 1/25th second, the exposure being regulated not by the shutter speed but by the flash duration. When faster exposures are needed, which is rare, the shutter must be set at a faster speed with a consequent loss of part of the flash light. Some shutters, as we have seen (page 87), have the M setting as well as the X, and this is used for fast shutter speeds of less than 1/30th second. Because the flash bulb takes a fraction of a second to reach its peak intensity, the M setting allows the bulb to be pre-ignited – that is to say, the bulb is given a little time to reach its full intensity of light before the shutter is opened.

A type of flash bulb is made specially for use with focal plane shutters as found on many 35 mm. cameras. Since the slit of a focal plane shutter takes time to cross the film's surface, the ordinary flash bulb will give only part of its light to the surface

126

of the film as the slit moves across it. This special type of bulb with a flash of long duration must be used with the shutter set at 1/30th or 1/25th second.

Many cameras have an accessory shoe on an upper surface into which a flash gun can be slid. When this is used the light will fall on to the subject from the front, and shadows will be very short and dense. In black-and-white this is generally undesirable for it produces a flat soot-and-whitewash effect; faces appear ghastly white and corpse-like. In colour this is less serious, but even so the result is flat. To obtain flash lighting away from the camera and to the side, two methods can be used. The first is to use a long connexion between gun and camera and continue to apply the shutter for synchronized ignition. The second is to use open flash; this means that you open the shutter, move away from the camera, explode the bulb independently of the shutter by pressing a button on the flash gun, return to the camera and close the shutter. If the subject is likely to move during the operation, there should, of course, be as little extra light in the room as possible. With open flash you can use as many bulbs as you like, and in different positions, to give extra light and more complicated shadows.

I dislike flash lighting myself and use it only where no other method of lighting is possible. But it is popular and easy to use after a little experience. It is particularly useful if you want to record life on the move indoors, perhaps at a party.

Both flash and tungsten lighting can be greatly softened by bouncing it on to a white ceiling or some other light surface, but then the exposure may have to be increased at least four times.

Blue flash bulbs (and electronic flash too) can be used in daylight to illuminate dark shadows as fill-in flash. Again I dislike the effect it often gives, for this can look very false. But to reduce contrasts in a room lit by daylight, fill-in flash can be useful.

Since a light meter cannot be used to measure flash light, accurate exposure must be calculated. Distance from flash to subject, type of reflector used, lack of reflector, film speed, shutter speed, accuracy of synchronization, reflections from walls and ceiling will all influence the calculation. The most important consideration, however, is the distance from flash to subject, because the light from a source falls off rapidly according to the inverse square law. This law states that the intensity of illumination on a surface is inversely proportional to the square of its distance from the light source. This means, for example, that a surface 10 feet away from a flash light will receive, not half the amount of light it would receive at 5 feet, but only a quarter. If the distance is trebled, the strength of the light will be only one ninth.

A useful tip: if the distance between flash and subject is multiplied by the *f*-number, the light on the subject will be available at *f*/8 and 4 feet as at *f*/4 and 8 feet, or at *f*/2 and 16 feet, the product of *f*-number and distance being 32 in each case.

The makers of flash bulbs issue tables giving Guide Numbers, or Flash Factors, for each type of bulb according to the speed of the film and the speed of the shutter. The higher the number, the more intense is the light. If the Guide Number is divided by the distance between flash and subject, the answer gives the required *f*-number. For example, if the Guide Number for a given bulb, given film speed, and given shutter speed is 50, and the bulb is to be ignited at 6 feet from the subject, the *f*-number will be *f*/8. But this will be only approximately correct, since other factors must be taken into account, such as wall reflections. A generous bracketing of exposures may often be advisable.

Here are tables of Guide Numbers for some popular types of flash bulbs used with a reflector in the flash gun for a domestic interior with light walls:

Blue Flash Bulbs (for Daylight Reversal Films)

Flash bulb Types	Shutter Speed and X or M Settings		Film Speed, ASA						
			10	20	32	40	50	100	160
PF 1B	1/25–1/30	X	40	58	70	80	94	136	160
1 BS	1/100–1/125	M	30	42	50	60	70	98	125
	1/200–1/250	M	22	32	40	45	52	80	90

Clear Flash Bulbs (for Negative and Artificial Light Reversal Films)

Flash bulb Types	Shutter Speed and X or M Settings		Film Speed, ASA						
			16	20	25	32	40	50	100
No. 1	1/25–1/30	X	36	40	45	50	56	62	90
PF 1	1/100–1/125	M	28	32	40	45	52	56	80
Type 1	1/200–1/250	M	20	22	25	28	32	36	50
No. 5	1/25–1/30	X	60	68	75	84	94	105	150
PF 5	1/100–1/125	M	50	56	63	70	80	88	128
Type 5	1/200–1/250	M	35	38	42	48	52	60	80

Note that with clear flash bulbs, Type F film, now apparently dying out, needs no filter. Type A film (for photofloods) needs Wratten No. 81C with $\frac{1}{3}$ extra stop, and Type B (studio lamps) needs Wratten No. 81D with $\frac{1}{2}$ extra stop.

An electronic flash gun is an apparatus having a special flash tube whose light approximates to daylight, its intensity being measured in joules. One joule equals one watt-second, so that a modest outfit of 25 joules would give a flash equal to a 25-watt tungsten bulb burning for one second, while an elaborate outfit might provide 1,000 joules. The most elaborate outfits can be flashed repeatedly and rapidly to provide stroboscopic photographs whereby, for instance, you could obtain a series of shots

on one picture to make an interesting pattern, perhaps of a dancer leaping into the air or a golfer swinging a club.

An electronic flash gun will give thousands of flashes before it needs recharging, and it can be run either off a battery or from the electric mains. It is mostly for professionals who need flashes constantly, but amateur models are obtainable. They are fairly expensive in capital outlay but are much cheaper to run than a flash gun. With electronic flash the X setting of the shutter must always be used, but, because the flash is very brilliant and brief (1/100th to 1/10,000th second according to the type), you can – at least on a lens shutter – use fast shutter speeds. Electronic flash has the advantage of freezing fast movement, and that can be especially useful when photographing children. It tends to produce soft results. The modest outfits do not give as much light as ordinary flash bulbs.

Portraits

Selective focus may be useful here by limiting the depth of field so that the subject is sharp and the background merely suggested by blurring. This, however, can be more effective in black-and-white than colour; in colour, it is more important to reduce the dominance of backgrounds by reducing the force of their colour. The face must be the focus of interest and the rest must not distract the eye too much. Backgrounds should, as a rule, be kept simple and flat.

Lighting is of prime importance in portraiture. Generally it should be soft, and deep shadows should be avoided. For women lighting contrasts of 3 to 1, or even 2 to 1 are not too small, but they can be increased for men to 4 to 1. Outdoors the light should be diffused, but if the sun is out it is best to let it shine over your shoulder so that deep shadows do not fall either on the face or the background. With studio lamps or photofloods, a single lamp may suffice, provided its light is

not allowed to produce harsh shadows. These can be avoided by bouncing the light by reflection from a white surface, by using a white reflector to counteract the intensity of shadows, or by diffusing the light source with glass-wool fabric placed in front of the lamp. Two lamps give more scope for interesting lighting than one, and three may be better still. But one lamp should be closer to the subject than the others; it should serve as the key light, the secondary lamps being used to reduce the shadow contrasts. Keep the key lamp slightly to one side and slightly above the head as a rule, but play about with all the lamps until you feel satisfied with the effect. Always remember that the eye will see less contrast than the film. Lighting from the back, but outside the camera's view, may be effective. So may a lamp shining straight down on to the hair. Spot lights can be useful to stress certain areas, possibly shining on to the background. Make sure that the lamps do not come too near the angle of view of the lens and so cause flare light in the picture; a piece of card clipped to the edge of a lamp's reflector will serve as a baffle.

As in all colour photography, the close view is generally better than a distant one, even if part of the head is cut off. Then a lens of long focus will serve better than a wide-angle lens or better even than a lens of medium focus, because then, since the camera will be further away from the subject, features will not appear distorted; a close shot with a wide-angle lens might, for instance, show the nose too prominently.

To flatter a face too broad at the top take a slightly lowered view and slope the camera up, and with a face too broad at the chin take a slightly elevated view and slope the camera down.

Beware of the reflective power of coloured surfaces. If close to the subject they may produce an unpleasant colour cast over the face, a cast which you may not notice but which the film will record.

Technical skill and visual sensibility are not enough in portraiture. Psychology is also needed so that a *rapport* can be

established between subject and photographer. Somehow you have to make the subject feel relaxed and unselfconscious. Talking without cease on matters which interest the subject may be one way of doing this, and then you must wait for that split second when the expression of the features is right before pressing the trigger. The candid shot taken when the subject is unaware of being photographed often produces good results, especially with children, but then you will need plenty of light and a rapid shutter to freeze the movements. When taking a young child, a coloured ball thrown into the air may concentrate its attention. With a particularly self-conscious sitter, a useful trick is to pretend to make the exposure and then, as soon as the sitter has relaxed, take the actual exposure. Widely smiling portraits can grow irritating to look at after a while, but make the subject laugh just before exposing because this relaxes the face muscles.

Landscapes

Strong, simple forms and colours are not always easy to discover in landscapes, and you should not be seduced too easily by romantic and literary associations and ideas. The mood of the light is important and so are cloud effects. A stormy sky when the sun comes out for a brief moment well to the side can produce great drama and strong forms and colours. Early morning or late evening, when the light is warmer and shadows are longer, are better than midday. Very distant views may benefit by reducing the exposure by half a stop or more. To obtain a sense of depth, include one or more objects in the foreground, perhaps in shadow.

In a mountain scene, or where the sense of size may be uncertain, try to include some object which gives a sense of scale to the whole, possibly a small building or a human figure or two.

Long-focus lenses are useful for landscapes, and so are

telephoto lenses with their exceptionally long focus. They increase the apparent size of mountains, for example. The longer the focus of the lens the steadier the exposure must be, since any slight camera shake will blur the image far more than it would when using a wide-angle lens. A sturdy tripod should be used and this can be made all the firmer by suspending a heavy weight from its head, possibly a large stone.

Snow presents special problems. In general, side lighting, or even *contre-jour* lighting, is the best, because then the textures and shadows are revealed. To neutralize blueness in the shadows use either a haze filter or a pale amber one. *Contre-jour*, or against the light, exposure can produce pleasant effects in outdoor photographs, for it makes for soft and subtle colours together with long shadows falling forward. Then exposure may have to be doubled.

Architecture

This can be divided into three overlapping categories: Survey, Illustration, Picture. The Survey is purely for recording purposes and is unlikely to interest the average amateur. The Illustration is a clear record of a building or a detail which also makes a pleasing picture in itself. The Picture is not at all concerned with clear record, its only aim being to make a pleasing composition depending for its power on architectural forms, textures and rhythms. In that sense, anything can be used to give an architectonic effect, from a pile of box lids to a bombed site. Indeed, to some extent all creative photography has a formal architectural quality; it is building with light.

As in all kinds of photography, a part of a building may be more telling than the whole; details rather than complete buildings often provide the most photogenic material. Again aesthetic virtue lies in selecting, isolating and framing part of the whole.

To convey a sense of depth by perspective and of three dimensions is important. Therefore side lighting is better than frontal, and this should fall in such a way that some surfaces are in shadow and others are lit. Unlike many subjects in colour photography, architectural ones generally prefer bright, clear sunlight, but not that from an overhead sun at midday when shadows are short.

Try to avoid views which look at a building at exactly 45 degrees. One façade should be turned towards you more than the other. And avoid tilting the camera at a slight angle, for then the verticals will appear to slope in the photograph. Maintaining verticals can be a problem with miniature cameras which (except for the Nikon mentioned) have no movements such as rising front or swing back by means of which the upper part of a tall building can be included in the frame and a dull foreground be reduced. A wide-angle lens will help, and part of a foreground can be cut off, or masked, in the photograph. If this is not enough, take a shot from higher up, perhaps from an upper window or on a hillside. If you are going to make a colour print, you can slope the camera upwards to include what you want and correct the verticals when making the enlargement by sloping the board of the enlarger and stopping the lens right down; some lengthening distortion will result, but this is rarely apparent and may even improve the building's proportions.

A tripod is almost essential in architectural work, not only to ensure that the camera is set square when you expose but because you may want to stop down a good deal to obtain a great depth of field, and then a slow shutter speed may be needed. For interiors a tripod will almost always be needed. Then the wide-angle lens comes into its own. If you are without a tripod and the light is fairly bright, you can press the camera hard against a wall or pillar to steady it – at least if the exposure is no more than a second or so. The main problem in interiors

is to reduce the lighting contrasts, and this may be difficult without artificial lighting. If the main illumination is daylight, dark shadows can be lightened by judicious use of blue flash bulbs, or photofloods with blue filters in front of them. Another problem is reciprocity failure, and that has already been dealt with on pages 107 and 116.

When photographing shiny metal, such as bronze, you must use diffused and reflected lighting or the highlights will be too bright and distracting, and the patina of the metal will be lost.

Candid Photography

The documentation of life on the move is really photo-journalism, but it can also be an art, as some of the great war photographers and others have shown. Black-and-white is generally the better medium for this than colour, but sometimes the subject depends for its drama or interest largely on its colours. Here, since movement is so rapid, you must rely on quick intuition for the moment of truth. You will probably have to waste many frames.

In a close place indoors, a good plan is to set your focusing at a fixed distance, say 6 feet, and than blaze away knowing by judgement what will come within the depth of field without bothering to adjust the focusing knob for each shot and so risk losing the significant moment. Photography like this needs great concentration, but can be fascinating and rewarding. In this kind of work the eye-level 35 mm. camera with a wide-angle lens giving good depth of field is the ideal instrument. And, of course, the faster the film is the better.

Abstractions and Experiments

Here colour photography is at its best. This is pure pattern making, especially in the close shot. The camera becomes a

135

wonderful tool for revealing images which have never been seen or noticed before, for discovering and communicating new harmonies.

Abstract photography, sometimes called Subjective photography, falls into two categories. The first is the detail which is already there and has been discovered and isolated by the photographer in his hunt for telling and exciting formal patterns. It is in a way the *objet trouvé*, the discovered object: things hanging on a wall in an unpremeditated pattern, part of an old wooden doorway rich with time's patina, a rock pool, ice formations on a window pane, a pattern of pipes in an oil refinery, a crumpled toffee foil, a translucent stone section seen through a microscope, a coloured ball seen through a mug of light ale, a coloured carton seen through a large condenser lens. The scope is infinite. This is the Abstraction.

The other category is the Abstract. This is the composition which has been deliberately formed by various means before exposure, perhaps after hours of experiment: lumps of glass discarded from a glass works through which coloured lights are played, a shot made not with a camera but with an enlarger in the dark-room of a composition carefully arranged on the board and using anything you can think of, such as cracked and splintered glass, mica, cellophane, drops of oil or water (the Photogram).

The main difference between the Abstraction and the Abstract is that the latter tends to concentrate on two-dimensional pattern, whereas the Abstraction, although mostly seeking flat pattern too, does bring in the third dimension in a shallow way, as texture. I feel myself that the discovered Abstraction is more interesting and more truly photographic than the contrived Abstract, in that it makes a comment by personal and perceptive selection upon new aspects of the world. The pure Abstract seems too close to the graphic arts while failing to allow the artist that complete freedom which brush

and pigment can provide. On the other hand, purely abstract photograms can suggest subjective feelings and ideas, and can stimulate the imagination.

Abstract photography is not new. In black-and-white at least, it has quite a venerable tradition. Although the American Paul Strand was making beautiful abstractions of close, but recognizable, objects a few years before him, A. L. Coburn made the first true abstracts in 1917, and these he called Vortographs. Others followed, notably by Man Ray and Moholy-Nagy of the famous Bauhaus school of design. The first photographic abstracts in colour appeared in the 1930s through photomicrography and macrophotography.

A new country of infinitely varied, exciting and beautiful landscapes in miniature, having the most subtle colours, exists to be explored by those who like to use their eyes adventurously. Photography like this can be tremendous fun, and it is available to the enthusiast all the year round.

All kinds of tricks and experiments are possible in colour photography – for instance, leaving the shutter open to capture chance patterns made in time by moving, coloured lights, such as fireworks – or using coloured lights or colour filters to make strange unnatural colour combinations – or solarization, bas-reliefs, harmonographs, line images, light-box images, high key and low key, the placing of a clear glass sheet in front of the lens with edges smeared with grease to produce blurring round the edge of the image, and so on. (Many of these off-beat tricks were explained in my Penguin *Photography*, and can be applied in colour as well as black-and-white.)

Many other kinds of photography exist other than those briefly described here, such as photomicrography, submarine photography, and the fine, bloodless sport of recording wildlife. Whole books have been published about each one of them describing the special techniques in detail.

Chapter 9 | *Processing and Printing*

Whole books have also been written about processing colour films and making colour prints. The subject is a large and complicated one and in this short handbook only the outlines of procedures can be drawn to show what is typically involved in the craft. Most reversal and negative films (excluding Kodachrome) can be processed, and colour prints made by the amateur using marketed kits of chemicals. All you need is a fair amount of time, space and patience, a little practice and strict adherence to manufacturer's instructions, especially in the control of temperatures.

Film Development

For processing a reversal film at home the bathroom can be used as dark-room with a board laid across the bath. You will also need the chemicals, a plastic funnel, five to seven glass bottles (preferably dark brown litre bottles), two graduated mixing vessels, a thermometer which can be inserted into the developing tank, a floodlamp, and one or more of those plastic developing tanks having colourless spiral holders, a glass or plastic stirring rod, an interval timer, some towels, and one or more clips for hanging up the films to dry after processing. The chemicals and methods vary slightly according to the make of film, but here is the procedure for a Ferrania reversal film using the special kit:

 (1) Mix the chemicals as instructed in the brochure in water

at 65° F. All the other solutions and changes of water should be as close as possible to 65 degrees.

(2) In complete darkness remove the film from its paper backing, push it by touch into the developing spiral, drop the spiral into its tank and place the light-tight lid on firmly. Switch on the light.

(3) Pour the first developer into the tank at 65° F, and develop for 14 minutes exactly, agitating with the twiddle stick for 10 seconds every minute. This is an ordinary black-and-white developer to reduce the latent silver images in the three layers.

(4) Wash for 5 minutes in 5 changes of water, keeping the lid on the tank.

(5) Pour out all water and pour in the hardening solution. Leave for 8 minutes, twiddling as before.

(6) Wash for 5 minutes as before.

(7) Remove lid, remove film from spiral and expose each side for 1½ minutes to a No. 1 photoflood lamp at a distance of 1 foot from the lamp, shielding your eyes from the glare and making sure that no drops of water fall on the lamp and explode it. This exposure will thoroughly fog all the residual silver salts of the emulsions not affected by the camera exposure.

(8) Run the film back into the spiral under water to ease its passage. Replace spiral in tank but do not trouble to replace the lid. Pour in the second developer and develop for 8 minutes, twiddling as before. Now the colours will be formed and coupled with the silver tones of the second exposure, but they will not yet be visible.

(9) Wash for 15 minutes as before, with a change of water every minute.

(10) Pour away the water and pour in the bleach-hardener. Leave for 10 minutes, twiddling as before.

(11) Wash as before for 5 minutes.

(12) Pour in fixer and leave for 10 minutes, twiddling as

before. All the silver deposits will dissolve, the film will become transparent and the colours will appear.

(13) Wash for 15 minutes as before. A few drops of wetting agent may be added to the final change of water.

(14) Remove film from spiral, attach film clip to one end, and hang up to dry in a dust-free, warm place, perhaps over the bath. Do not dry in front of a fire.

The processing of a negative film is easier and temperature controls need not be so precise. Here the steps are likely to be: (1) Develop, (2) Wash, (3) Stop-harden, (4) Wash, (5) Bleach, (6) Wash, (7) Fix, (8) Final wash, (9) Harden-stabilize. In some procedures steps 5 and 7 can be combined. Note that a negative film is not exposed to a flood lamp after the first development, and there is no second development, the negative colours being produced during the first step. With Agfacolor negative film, two developers are needed, one following immediately after the other.

Treatment of Transparencies after Processing

Reversal transparencies can be mounted in special cardboard holders, but they do not protect the surfaces. Standard ready-mounts with plastic or metal frames and two glasses can be obtained for both the 35 mm. size and the $2\frac{1}{4}$ ins. square size. The former are about 2 ins. square (4 mm.), and so they take either the standard 35 mm. format or the Superslide format – any size, in fact, within the 2 ins. square, provided a suitable framing mask of black paper or foil is incorporated. The full size taking the $2\frac{1}{4}$ ins. square transparencies is $2\frac{3}{4}$ ins. square, and suitable masks must be used here too.

Some makes of projector accommodate both sizes of slide; others one or the other, and many projectors have automatic feeders. If you have a good camera with a fine lens, it is foolish to buy a cheap projector since its lens will be poor and it may

not have a cooling fan; without such a fan slides may become over-heated and ruined. The older projectors, or magic lanterns, take the original standard British lantern slide measuring $3\frac{1}{4}$ ins. square, and there is an American size of $3\frac{1}{4}$ by 4 ins. Such projectors are now rare. They can be fitted with adaptors to take the smaller slides of today.

Better than using standard mounts – easy as these are to handle – is to mount transparencies between glasses and, having masked them, to bind the edges of the glasses with strips of gummed paper. Then no dust will penetrate to the transparency. Glasses are obtainable in packets of fifty in four standard sizes, and so are masks made either of black paper or foil. Foil is better because it absorbs less heat from the projector's lamp than the black paper, and it gives cleaner edges around the picture. Small bulldog paper clips will help in mounting slides in this way, and a large sable-haired water-colour brush can be used to remove dust from the surfaces of transparencies and glasses before mounting.

Self-adhesive white spots are obtainable to stick on to slides for numbering, and so are small, long labels for lettering. The white spot is also useful for marking the correct way up when inserting the slide into the projector holder, the convention now being to stick it on the bottom left-hand corner when looking at the slide as it would appear on a screen.

Some after-treatment of transparencies is possible. For example, if one has been damaged during processing or has a few dust spots, some spotting with coloured dyes and a fine brush is possible, though this needs practised skill. Colour casts can be neutralized by binding in a coloured gelatine filter with the transparency when mounting. The filter will tend to absorb its complementary colour and strengthen its own. The whites will, of course, be affected by the filter, but, when viewing the projection of a slide, the eye will not notice it if it is fairly pale. A yellow filter reduces (absorbs) blue and

violet; green reduces red; blue-green reduces orange; blue-violet reduces yellow; purple reduces green; red reduces blue-green; salmon pink reduces blue. The Kodak colour compensation filters as listed on page 115 will serve well.

Transparencies which are too dense can be reduced by a new product called Colorbrite. It either reduces the density of the three layers equally up to the equivalent of one additional diaphragm stop, or it reduces one or two of the colours individually so that colour balance can be helped. This is costly stuff at £12 for a 16 oz. bottle, but it can be used repeatedly until exhausted. Kodak and other makers also produce selective bleaches which help to restore colour balances.

Colour Printing

The Kodak Dye Transfer system with its three relief matrices is the last survivor of the early systems of photographic colour printing, and from this the best results can be obtained. But it requires much skilled handicraft, and prints done professionally are expensive. Up to one hundred prints can be made from the same matrices. The dye transfer prints fade less rapidly than the new tri-pack prints, not only because the dyes can be better but because residual chemicals are not left in the paper as they are unavoidably with the processed tri-pack papers. Moreover, the system allows considerable control of colours.

The new printing systems depend on integral tri-pack papers. None are yet fadeless. The Cilchrome paper made by the Swiss firm of CIBA, which was released in 1964, appears to fade less than most other papers, being based on the new azo dyes, which also resist humidity and acids in the atmosphere. The stability of these dyes can be compared with that of the so-called fadeless textile dyes. A Cilchrome print can be produced directly from a positive transparency by a dye-bleach process, no second exposure or second development being required. Negatives can

also be printed on the paper but then a second reversal development is needed before dye bleaching.

A remarkable new colour printing system called the 3M Electrocolor process, which at time of writing is in its field testing stage by the Minnesota Mining and Manufacturing Company, holds promise for the future. This uses no silver halides at all, being based on electrical charges. Three exposures are made through tri-colour filters, and a print can be made in five minutes. The colours are as permanent as those of 'fadeless' textiles. Apparently the cost of the equipment will be comparatively high.

Meanwhile, Kodak's Ektachrome and Ektacolor papers are among the most stable of the conventional tri-pack papers. Protective lacquers can be obtained to spray on any colour print and this will add at least 50 per cent to the length of life of a print, since it cuts off the ultra-violet rays, which are the main cause of fading, even from artificial light.

Here, broadly, is the procedure for making a colour print on tri-pack paper from a colour negative. Most good enlargers can be used provided they do not spill out any light, have a lens corrected against colour aberration, and, if possible, have a filter drawer built in the lamphouse between the lamp and the negative holder. Alternatively, the enlarger must have either some arrangement to take the printing filters below the lens, or an easily made mask to hold the filters to rest on top of the enlarger's condenser lens. A good model for colour printing is the Kodak Colour Enlarger which will take negatives up to $2\frac{1}{4}$ by $3\frac{1}{4}$ ins. and has filters built in.

For a start at least, it is as well to use the paper for which a film has been designed – Agfa paper for Agfa film, Ektacolor for Kodacolor film and so on, because film and paper will be matched in their colour balances. The same maker's filters should also be used and their chemicals.

Some colour correcting by filtering is almost always necessary

when making a colour print. Two methods are possible. The first, called tri-colour, is to use only three filters: red, blue, and green, giving three exposures of adjusted lengths through each filter in turn. Then the difficulty is to avoid jarring the enlarger head when moving the filters. A better method, called white-light, is to use one filter, or two filters together, which have been selected from a whole stack of filters of varying degrees of saturation, and then giving a single exposure. An advantage here is that, as in black-and-white work, parts of the image can be controlled locally during exposure by dodging, shadowing and burning in.

Printing paper must be handled either in complete darkness or with only a very dim safelight having an Agfa No. 166 or a Wratten 10H screen. The length of the exposure, as in black-and-white, controls the density of the print. The filters may be limited to a range of six of each of the subtractive colours: yellow, magenta and cyan, or they may also include a range of six in red, blue and green, thus making a total of 36 filters from which to choose. Any colour cast revealed on a test print can be reduced either by adding the same colour to the filtering or subtracting its complementary colour from the filtering. An excess of blue in the print requires the addition of blue to the filtering (magenta plus cyan) or a subtraction of its complementary which is yellow. An excess of green requires an addition of green (yellow plus cyan) or a subtraction of magenta. An excess of red requires an addition of red (yellow plus magenta) or a subtraction of cyan. An excess of yellow requires an addition of yellow (red plus green) or a subtraction of magenta plus cyan (blue). An excess of magenta requires an addition of magenta (red plus blue) or a subtraction of yellow plus cyan (green). An excess of cyan requires an addition of cyan (blue plus green) or a subtraction of yellow plus magenta (red).

If the filters are placed below the enlarger lens, both primaries and secondaries can be used as comprised in the Kodak

colour compensation (CC) series. If placed between lamp and lens, the secondaries (yellow, magenta and cyan) alone are used as in the Kodak colour printing (CP) series. Ultra-violet and infra-red filters should also be used for every print, these being placed below the lamp to remove unwanted U.V. rays and to reduce the lamp's heat.

First, one or more test prints are made in the enlarger without any filters, mainly to assess the correct length of exposure. More tests are made with one or two selected filters to provide any colour correction needed, extra time being allowed for the exposure according to the filter factors. (For a good negative under a 150-watt lamp a three-times enlargement at $f/8$ without filters might be around 12 seconds.)

Instead of handling a stack of loose, delicate filters, a more satisfactory method can be used – that of the colour enlarger head by means of which the colour of the illumination can be quickly and easily adjusted. Agfa produce such a head, which has three knobs to regulate the yellow, magenta and cyan filters.

When a negative has too much contrast to print well, the contrast can be reduced to an acceptable level by making a positive mask and superimposing this on the negative when printing. The mask is made by contact-printing the colour negative on a sheet of special film such as Kodak Pan Masking Film. The exposure can be made in a contact-printing frame on the baseboard of the enlarger, as though you were making a black-and-white negative from a reversal transparency.

The processing of colour prints is similar to that for colour negatives and special kits are also available. Agfa now produce a short process which consists of five baths only: developer, stop-fix, bleach-fix, wash and stabilize. (Normally you need: developer, wash, bleach-fix, wash, hardener, wash, buffer, wash and stabilizers.)

Black-and-white Prints from Colour Films

Ordinary black-and-white bromide paper cannot be used successfully to make a black-and-white print from a colour negative because the paper is sensitive only to blue; it is not panchromatic and so the tones will be incorrect. But a special panchromatic paper called Panalure is produced by Kodak from which excellent black-and-white prints can be made from colour negatives. It is made in only one grade, but two surfaces are available: glossy and fine white lustre. Being panchromatic, the paper must be handled in a dim safelight with a Wratten 10 H screen. An advantage of Panalure is that it enables black-and-white prints to be made from colour negatives with colour filters so that the tones can be controlled to a greater extent than they can be when making bromide prints from black-and-white negatives.

A black-and-white negative can be made quite easily from a reversal transparency. Use either cut film or cut a piece of the right size from a roll film. Cut film is preferable because roll film tends to curl and may be difficult to handle. The film must, of course, be panchromatic and be fairly slow for the sake of fine grain. In complete darkness, place the film in contact with the transparency in a contact-printing frame with the emulsion sides facing each other. Lay the frame in the centre of the enlarger board, close the lens stop well down, and switch on the enlarger light. Expose for about ten to twenty seconds, the correct exposure being a matter of experiment. The film is then developed, fixed and washed in the normal way, but a soft developer is best and development time should be restricted to about two thirds of the normal in order to avoid too much contrast.

Retouching Transparencies and Prints

The meticulous amateur may want to alter or touch up his finished products. One way of altering the colour balance of a transparency has already been mentioned – the binding of a gelatine sheet of pale colour over the picture. Another way is to soak the transparency in a dilute dye solution of a colour complementary to the cast to be eliminated. A third way is to use selective bleaches to reduce one or more of the three dyes. To retouch small, local defects, the area can be bleached with a brush and then the desired colour added with pencils or dyes; alternatively, no bleach may be needed and the defect be merely blended with coloured pencils or dyes into the surrounding area. These matters are fully discussed in a Kodak pamphlet, *Retouching Colour Transparencies*.

White dust spots and other faulty areas of prints can be retouched with sable-hair brushes and special dyes like Johnson's photocolours or Ilford's dye retouching set. Larger areas can be treated with Kodak's Flexichrome colours. The colours should in general be dotted on, using a fairly dry brush, and it is safer to apply several pale applications than a single one which may be too saturated or of a slightly wrong hue. To neutralize a colour, its complementary dye, of course, is used. The Kodak booklet, *Colour Printing from Colour Negatives*, is helpful on this subject and on colour printing in general.

Conclusion

However many books like this you read, only experience and practice will give you perfect technique. Even then the first need is visual sensibility. Nothing is so depressing as perfect technique applied merely as an end in itself. Technique is only a means. The end is personal expression.

The Pictures

The Cover

Bridge Sign by Eric de Maré. Selected as a jacket partly because it catches the eye – the circle being the most powerful of shapes and red the most arresting of colours. Selected also because it is an example of an abstract composition that any amateur with his eyes open can discover in the world around him anywhere and at any time. The shot shows the warning disc on a road bridge across the Göta Canal, Sweden, and it was taken on the old Kodachrome I film in a Rolleiflex adapted with a Rolleikin set to accept 35 mm. film, thus rendering the lens one of long focus. The back of the jacket shows the shot in negative form.

Portraits

Plate 1 *Portrait Group* by Heinrich Kühn. From an Autochrome reproduced in the special summer number of *The Studio* published in 1908 and entitled 'Colour Photography and Other Recent Developments of the Art of the Camera'. The introduction by Dixon Scott comments: 'The Clark-Maxwells and the Lippmanns laboriously shaped the shaft, brought the principles together, and hammered them roughly into shape. It was left to the Lumières to fit the pungent barb and so, with one deft touch, transform a rude and barbarous curiosity into a glittering revolutionary weapon ... Starch-grains coloured green, starch-grains coloured violet, and starch-grains coloured orange ... are equally commingled, so that they seem to form a uniform grey dust, and are then adroitly marshalled, some four millions to the square inch, on the surface of a single plate; and it is over this fabulous army that the sensitive film of

148

panchromatic emulsion, the chemical prison which captures the image, is delicately outstretched. The result of this elaborate and perfect ambush is a complete surrender on the part of the colour rays . . .'

Plate 2 *Sicilian Bride* by Stefan Buzas. A common wedding custom in Palermo is for bride and groom to be photographed within this old carriage in the local (and remarkable) Museum of Folk Art. Buzas is a distinguished architect and, like many architects with trained eyes, he is an amateur photographer of rare perception. This shot and all the others on these pages were chosen not only because the author liked them but because their colours, not least when gentle, provide a new dimension which would have been lost in black-and-white.

Plate 3 *Princess Anne at 21* by Norman Parkinson (Camera Press). This is one of a series by a distinguished fashion photographer taken on the Princess's twenty-first birthday and published in the Sunday colour supplements of 15 August 1971. Photographing royalty cannot be an easy assignment, but here the problem has been admirably solved – regal dignity being preserved without loss of youthful freshness or expression of personal entity.

Landscapes

Plate 4 *Scottish Mountains* by Fred Mayer (Magnum). One of four shots taken on 35 mm. film to represent the Four Elements and blown up with the use of larger intermediary transparencies to make a set of posters for Wiggins Teape, paper manufacturers. This lovely landscape with its restricted colours and its silhouetted planes receding into the distance represents the element Air.

Plate 5 *Landscape with Ruin* by Ray Moore. This lyrical scene on Skomer Island, Pembrokeshire, was taken on Ferrania film with a twin-lens reflex. Moore began his career as a painter but has become a fine, dedicated photographer and lecturer in charge of photography at the School of Art, Watford.

149

Patterns of Nature

Plate 6 *Abalone Shell* by Ernst Haas (Magnum). This seems to represent a landscape of immense proportions but it is, in fact, only part of the inside of the shell – a straight shot taken with a Micro-Nikkor 55 mm. lens outdoors in the reddish glow of sunset. It first appeared, both on the jacket and within the volume of *The Creation*, illustrated by this celebrated photographer.

Plate 7 *Ribbed Hosta Leaf* by Alfred Lammer. One of many close shots of flowers and plants – a field in which this photographer, who is also a teacher, is now specializing. It was first published with other examples in *Penrose Annual*, 1972. By fixing his Leicaflex courageously close to his subject, Lammer reveals fascinating abstractions which the eyes on their own would not see in the same way. He has TTL (through the lens) metering to give precise exposure and to save time, and he uses three lenses: a normal 50 mm. Summicron R for the closer hand-held shots to which achromatic attachments Elpro VIa and VIb can be added – a 90 mm. Elmar f/4 and a 65 mm. Elmar, both needing bellow extension and a tripod. Mostly he uses Ektachrome film without a filter and sometimes Kodachrome II with which at midday he applies a Wratten IA filter to cut out excess blue. He exposes in diffused light, rather than in direct sunlight, in order to eliminate unwanted shadow casts that might confuse the pure forms and the saturated colours. And he always photographs his subjects in their natural settings.

Plate 8 *Microphoto of a Holly Leaf* by Augustus Lunn. A very close shot on 35 mm. Kodachrome A film of a small area of the skeleton of a holly leaf makes this interesting abstract pattern. Microphotography is a special and inspiring field well within the scope of the amateur who can obtain a microscope and a good light source controllable by filters (including a polarizer). Lunn is a mural painter, a glass engraver and a teacher. In his own words: 'I take a very small piece of a very

150

small object and then, by removing it from its context, I create something else. The eye by itself is unable to see such things and so the camera becomes a valuable tool in the hands of the designer.'

Patterns of Structure

Plate 9 *Painted Steel* by Eric de Maré. One of a series taken for the Steel Company of Wales at Port Talbot. The rigid geometry of technology seems to imprison the tiny human figure in the background. Taken on Ektachrome 120 film in a Linhof Technika with a wide-angle lens.

Plate 10 *The Forth Railway Bridge* by Eric de Maré. Another piece of painted steelwork taken from the top of one of the towers shortly before the steam engine vanished from the tracks. The shot of the splendid structure, snapped with a Rolleiflex on Ektachrome film, captures in its angle of view and its symmetry an effect of dramatic monumentality. It was originally taken for the British Iron and Steel Federation as one of a series and was used on the jacket of Lord Clark's book, *Civilization*.

Sport

Plate 11 *The Huddle* by Cornell Capa (Magnum). A powerful, wide-angle shot of an American football scrum, having a curiously restricted colour range. It was taken on a 5 ins. by 4 ins. transparency by one of *Life* magazine's distinguished photographers.

Travel

Plate 12 *Doorway* by Ray Moore. A twin-lens reflex shot taken in a Victorian cholera hospital on Flatholm Island in the Bristol Channel, now an eerie ruin.

Plate 13 *Balloon Race* by Ian Berry (Camera Press). Taken

during an international race above the English fields. It appeared originally on the cover of the *Observer* colour supplement.

Plate 14 *Venice* by Eric de Maré. The kind of picture any amateur might take on holiday with a little care. It has certain virtues: the sky blue is gentle and avoids the brashness of the picture post-card; the light falls on one plane only of the distant buildings, giving solidarity; the whole is firmly framed by the posts; a sense of depth is provided by the close foreground objects; the colours harmonize without being dull; and cutting the picture precisely in half by the horizon is avoided. Anscochrome 120 film in a Linhof Technika.

Plate 15 *Norwegian Fjord* by Ernst Haas (Magnum). Taken on 35 mm. film this shot has been deliberately placed on its side to give an effect of a brilliantly, yet harmoniously, coloured piece of abstract sculpture.

Plate 16 *Portuguese Village* by Geoffrey Ireland. An example of the aesthetic power of photography to select, frame and isolate from its surroundings an immutable unity. This is a finely composed piece of architecture which would have lost much of its force in black-and-white, even though its colour range is restricted. Ireland is a teacher of art and, like Lunn, finds photography a stimulus to designing in general. Agfacolor 35 mm. film.

Recording Works of Art

These two pictures are included as examples of the recording on colour film of works of sculpture and painting which many amateurs may want to accomplish on their travels. Both were taken on Anscochrome 120 film in a Linhof Technika using a lens of medium focal length. Recording is largely, though by no means entirely, a matter of careful technique; some aesthetic sensibility is required in selection of viewpoint, selection of lens, selection of part of a whole to make a strong composition in itself, choosing a suitably coloured and textured background,

and particularly in judicious lighting which is a matter as much of instinct and experiment as of reasoning and rule.

Plate 17 *Ormolu Bust* by Eric de Maré. This flattering portrait of George IV was cast to commemorate the king's Coronation. One of a series made for Lund Humphries Ltd to illustrate the official catalogue of the Royal Pavilion, Brighton. They were all taken with a Linhof Technika on Anscochrome 120 daylight film with a blue filter over the lens for adjustment to studio lamps; so the exposures had to be increased five times – an unorthodox method but owing to the tolerance to reciprocity failure in long exposures of the film the colour rendering was perfect. Bright metal is difficult to photograph, particularly bronze, and is best done in reflected or diffused light to reduce the glitter of highlights. Here two large reflecting bowls were used with lamps of 1,000 watts covered over with metal disks to make the shadows gentle. Regal splendour is suggested by contrasting the gilt with a rich background of red damask.

Plate 18 *Painted Ceiling* by Eric de Maré. A selected detail of the famous work by Rubens at the Banqueting Hall, Whitehall, which was commissioned by Charles I and completed in 1634. It depicts the Apotheosis of James I and this detail represents the Union of England and Scotland with Minerva holding a crown over the infant. This was a tricky shot owing to the mixed colour temperatures of the lighting which included daylight, ordinary tungsten and a few photofloods placed in the galleries. Balance on the daylight-type film was achieved empirically by holding a blue filter over the lens during part of the long exposure with a small stop in order to add the necessary correction to the artificial lighting. The camera was placed on a tripod close to the ground. The author boastfully records that here he achieved single-handed and in a simple manner the first photographs that revealed the ceiling in its correct colours – after teams of professionals with lavish equipment and at great cost had failed. The shot was one of many taken for Batsford to illustrate the author's picture book, *The City of Westminster: Heart of London* (1968).

Infra Red

Plate 19 *Ships in Harbour* by Howard Sochurek (Magnum). A curiosity taken from the air on infra-red film and the sort of picture even the most advanced of amateurs is unlikely to attempt, but of general interest in depicting the revelatory powers of photography. Here rays not visible to the human eye record a pattern in false colours of ships in harbour at Norfolk, Virginia. Although the picture possesses a strange beauty in its forms and colours, it is an example of a photograph used for scientific investigation. The vivid red of the trees along the waterfront shows that they are broad-leafed and extremely healthy.

Index

Index

156

157

Index

Index